Christo and Jeanne-Claude THE WÜRTH MUSEUM COLLECTION

November 3 through December 31, 2005

On the heels of their successful Gates project in Central Park in New York last February, this exhibition surveys five decades of the work of Christo and Jeanne-Claude, These inventive international artists have captured the imagination of the contemporary art world by wrapping monumental buildings. draping the pristine landscape with fabric, and engaging the public in a dialogue about the very nature of modern art

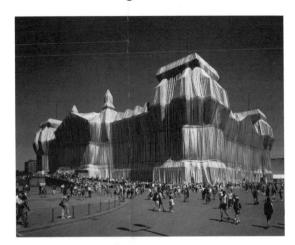

This exhibition of more than 80 objects provides an opportunity to see the entire artistic process of Christo and Jeanne-Claude, including small preparatory sketches, large collages, small-scale completed projects and wrapped objects, and photographs of large-scale finished projects. All of the objects were collected by manufacturing magnate Reinhold Würth and have never been seen together in the United States. Projects represented include: Wrapped Coast, Project for Australia, Little Bay; Valley Curtain, Project for Rifle, Colorado; Running Fence, Project for Sonoma and Marin Counties, California; Surrounded Islands, Project for Biscayne Bay, Greater Miami, Florida; The Pont Neuf Wrapped, Paris; The Umbrellas, Joint Project for Japan and USA; Wrapped Reichstag, Project for Berlin; and

The huge public art projects created by Christo and Jeanne-Claude are often only in place for a few weeks, after which the project is kept alive by documentary records in the form of films, photography, drawings, and collages. Responsibility for financing lies entirely with the artists, who use funds from the sale of preliminary drawings, collages, editions, or earlier works produced in the 1950s to support each new project. They do not accept sponsorship of any kind for their work. Once an

The Gates, Project for Central Park, New York.

event has finished, the landscape or architectural feature is returned to its original state.

Both artists were born on June 13, 1935, he in Gabrovo, Bulgaria, and she in Casablanca, Morocco. After studying at the Fine Arts Academy in Sofia, Christo left Bulgaria in 1956. He went first to Prague, then Vienna and Geneva, ending up in 1958 in Paris, where he met Jeanne-Claude, who holds a degree in Latin and

Philosophy from the University in Tunis. Inspired by Russian artist Tatlin's constructivist notion of utilizing "real materials in a real space," Christo began "wrapping" everyday objects in the late 1950s. As the scale of the projects became larger and more complex, eventually he and Jeanne-Claude began to work collaboratively. In 1964, they moved from Paris to New York, where they still reside.

One of their more notable projects was the Wrapped Reichstag, Berlin, first conceived in 1971, but not finally realized until 1995. Because of the political implications, the project took a long time to plan and caused an enormous public stir. Situated on the dividing line between East and West, it symbolized both division and democracy. Before the wrapping of the Reichstag drew crowds of spectators to Berlin, however, Christo and Jeanne-Claude had already staged a project at the headquarters of the Würth corporation, shrouding the floor and stairs with cotton cloth, covering the windows with brown wrapping paper, and covering up the furniture. The installation affected the corporate culture of the firm, promoting an intense, sensory experience and provoking heated discussions between staff members and the public—the ultimate goal of any successful Christo and Jeanne-Claude project.

2005 Bernard A. Osher Lecture: An Evening with Christo and Jeanne Claude

Wednesday, November 9, 6:30 p.m., Merrill Auditorium, 20 Myrtle Street, Portland. Tickets are \$15 at Porttix.com. Museum member tickets are \$10 by calling the ticket office at (207) 842-0800.

Join us to hear directly from the artists about the intricate process behind their temporary and transformative works of art. Christo and Jeanne-Claude will be available for a booksigning immediately following the lecture at Merrill Auditorium. They receive no income from the sale of books.

The lecture is made possible through the Bernard A. Osher Lecture Fund.

Gallery Talks

Saturdays, November 12 and December 3, 2 p.m. Free with Museum admission.

11/12: Christo and Jeanne-Claude: What do You See? presented by Vera Tashima

12/3: *Christo and Jeanne-Claude: It's a Wrap!* presented by John Fatula

Wrap up the Year!

Saturday, December 10, 1 p.m. to 3 p.m. Free with Museum admission for adults and children of all ages.

Drop in to the Museum during your holiday shopping in the city, and make it a wrap! Join our gathering of families and friends for some hands-on fun designing and printing handmade giftwrap and cards for the season.

Christo and Jeanne-Claude on Film

Friday, November 18, 6:30 p.m., Saturday, November 19, 11 a.m. and 1 p.m., Auditorium. Cost: \$5/session. Tickets available online at portlandmuseum.org. Come see these fascinating films by award-winning documentary filmmaker Albert Maysles.

Session 1: Friday, November 18, 6:30 p.m.

• Umbrellas © 1995, 81 minutes.

Session 2: Saturday, November 19, 11 a.m.

- Islands, 1986, 57 minutes.
- Christo's Valley Curtain, 1974, 28 minutes.

Session 3: Saturday, November 19, 1 p.m.

- Christo in Paris, 1990, 58 minutes.
- Running Fence, 1978, 58 minutes.

SELECTED READING

All books are available in the Museum Store.

Christo and Jeanne-Claude, The Würth Museum Collection

This 128-page fully-illustrated exhibition catalogue features international projects from the Würth Museum collection and chronicles the extraordinary oeuvre of Christo and Jeanne-Claude over the past five decades. (paperback, \$29.95)

Christo and Jeanne-Claude, On the Way to The Gates, Central Park, New York City

This 214-page catalogue, published by the Metropolitan Museum of Art, not only celebrates the culmination of the artists' vision for *The Gates*, but also surveys the entire career of Christo and Jeanne-Claude and assesses their contributions to contemporary art and culture. (paperback, \$45.00)

Christo and Jeanne-Claude, The Gates, Central Park, New York City, 1979-2005

This newly-revised, 128-page full-color catalogue provides complete documentation of the highly celebrated *Gates* project in Central Park, from its conception through its amazing installation. (paperback, \$29.99)

The exhibition is lent by the Museum Würth, Künzelsau, Germany. The exhibition tour is organized by the Trust for Museum Exhibitions, Washington, D. C. Media support has been provided by Mainebiz.

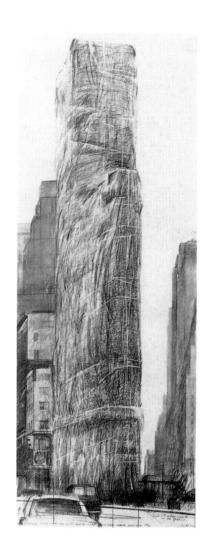

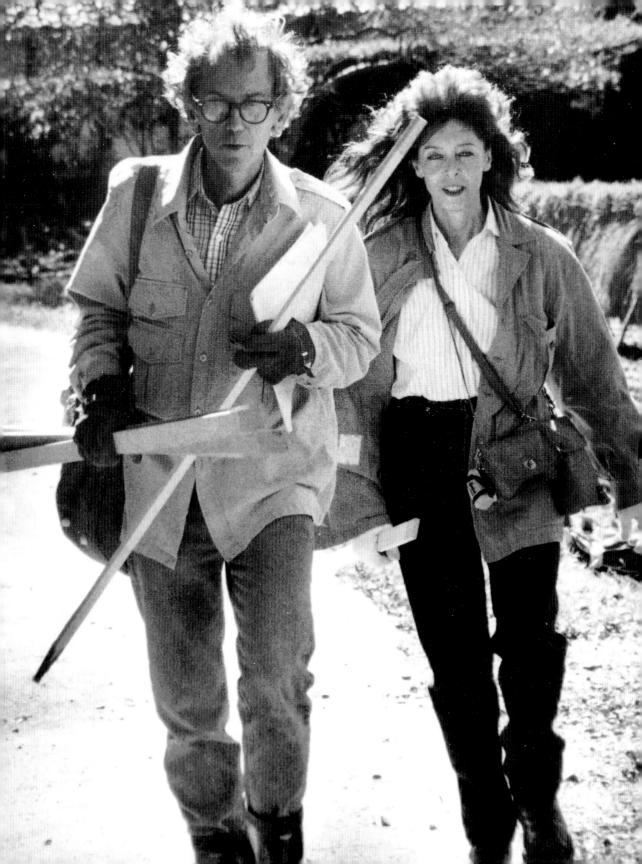

Jacob Baal-Teshuva

Misto and Jeanne-Claude

Photographs by Wolfgang Volz

FRONT COVER:

Wrapped Reichstag, Berlin, 1971–1995 Polypropylene fabric and blue rope, 135.7 m x 96 m

PAGE 1:

Wrapped Building, Project for Allied Chemical Tower, New York Drawing, 1968

Pencil, charcoal and wax crayons, 244 x 91.5 cm New York, Collection Adrian Keller

PAGE 2 AND BACK COVER:

Christo and Jeanne-Claude in Oktober 1988, during the staking of the locations in Japan for *The Umbrellas*, Japan - USA, Ibaraki, Japan Site

> To my wife Aviva with love Jacob Baal-Teshuva

Unless otherwise indicated, the original works belong to the artists.

Um sich über Neuerscheinungen von TASCHEN zu informieren, fordern Sie bitte unser Magazin unter www.taschen.com an, oder schreiben Sie an TASCHEN, Hohenzollernring 53, D–50672 Köln, Fax: +49-221-254919.

Wir schicken Ihnen gerne ein kostenloses Exemplar mit Informationen über alle unsere Bücher.

Original edition
© 2001 TASCHEN GmbH
Hohenzollernring 53, D–50672 Köln
www.taschen.com

© 2001 Christo, New York

© 2001 for the photographs: Wolfgang Volz, Düsseldorf
© 2001 VG Bild-Kunst, Bonn, for the work by Man Ray
© 2001 The Henry Moore Foundation, Hertfordshire, for the work by Henry Moore

Edited by Simone Philippi and Charles Brace, Cologne Design: Simone Philippi, Cologne Cover Design: Catinka Keul, Angelika Taschen, Cologne

> Printed in Germany ISBN 3-8228-5996-6

Contents

6
Introduction

10
"Miserable autumn weekends"
Out of Bulgaria

14
"Revelation through concealment"
Paris

26
"Tributes to artistic freedom"
Store Fronts, Air Packages, Wrapped Museums

38
"The quintessential artists of their time"
Wrapped Coast, Valley Curtain, Running Fence

"The only natural choice"
Surrounded Islands, Pont-Neuf, The Umbrellas

76 The Reichstag, Wrapped Trees, The Wall

88
"This is reality"
Work in progress

94 Christo and Jeanne-Claude – Chronology

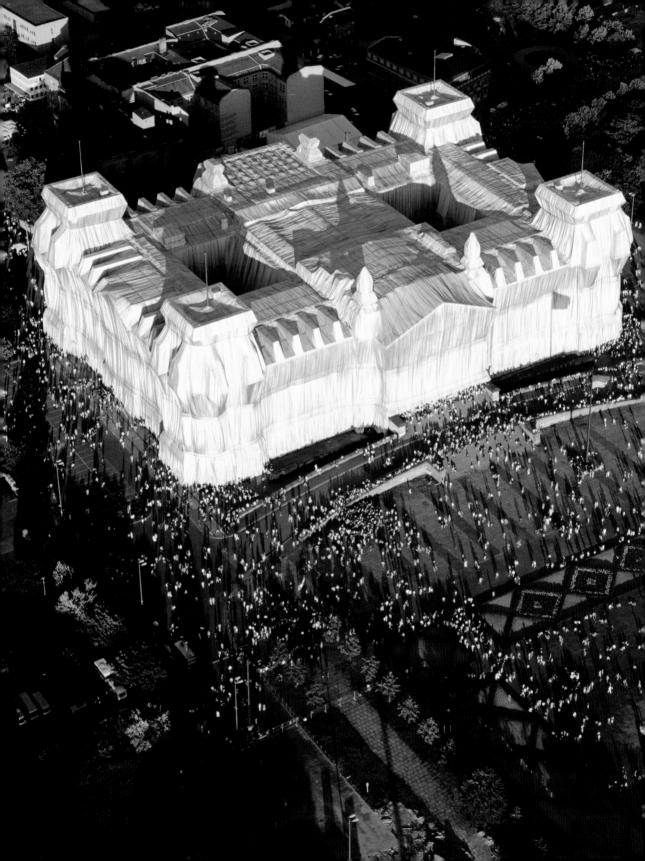

On February 25, 1994, I was awakened at six in the morning by the fax machine. The message, from Christo's indefatigable collaborator and partner Jeanne-Claude, was one I had long been waiting for: "WE HAVE WON!" Permission had been granted to create the temporary work of art *Wrapped Reichstag*, *Berlin*. The vote was 292 in favor, 223 against, with 9 abstentions.

The vote had been won against all odds. During the debate, Christo sat in the visitors' gallery with some of his collaborators, following the arguments with the help of an interpreter. It was the first time in history that an unrealized work of art was being discussed and voted on in the German Bundestag – or for that matter, in any parliament. Furthermore, success had been achieved against the will of Chancellor Helmut Kohl, who had voted against the project. Throughout the discussion, he remained adamant in his opposition, and even refused to meet with the Christos or answer their letters. Now, after 24 years of efforts and lobbying, the Christos had won a great victory: permission to wrap the Reichstag prior to its becoming, once again, the German parliament building. The realization of the project became a spectacular event, drawing five million people to Berlin. Viewing it at all hours of the day or night, visitors were reminded of Claude Monet's series of paintings of the Rouen Cathedral in France, which depict the building at different hours of the day.

The question is frequently asked, "How do you define the work of Christo and Jeanne-Claude? How do you classify it?"

To many people, the Christos are perceived par tout as wrappers of buildings, bridges, and other objects. But this view is too simplistic. The project *The Umbrellas, Japan – USA*, for example, had nothing to do with wrapping. The same holds true for the *Surrounded Islands* project: in this case, the Christos surrounded eleven islands in pink fabric.

There are several inherent elements in the philosophy behind *Wrapped Reichstag* as well as many others of the Christos' projects that function as temporary works of art. (Aside from these, the only remaining works consist of films, books and Christo's drawings, collages, and scale models, which are to be found in museums throughout the world and in private collections. From the sale of these preparatory works, the Christos finance their projects.) The major elements in the philosophy behind both this work and the many projects of the Christos are:

1) Painting and the elements of paintings. A good example is the project *Surrounded Islands*, *Biscayne Bay*, *Greater Miami*, *Florida* (1980–1983, p. 54). Flying over it with a helicopter, I was reminded of the water-lily canvases by Claude Monet: Biscayne Bay functioned as the Christos' canvas.

2) Sculpture and architecture. The spectacular project *Wrapped Reichstag*, *Berlin* (1971–1995), can be seen as a huge monumental sculpture and work of

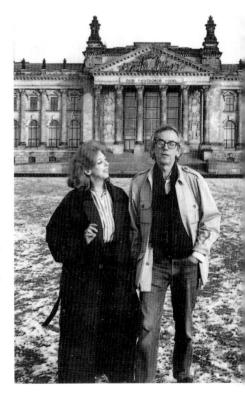

Jeanne-Claude and Christo in front of the Reichstag in Berlin, 1993

PAGE 6: Wrapped Reichstag, Berlin, 1971–1995 Aerial view Polypropylene fabric and blue rope

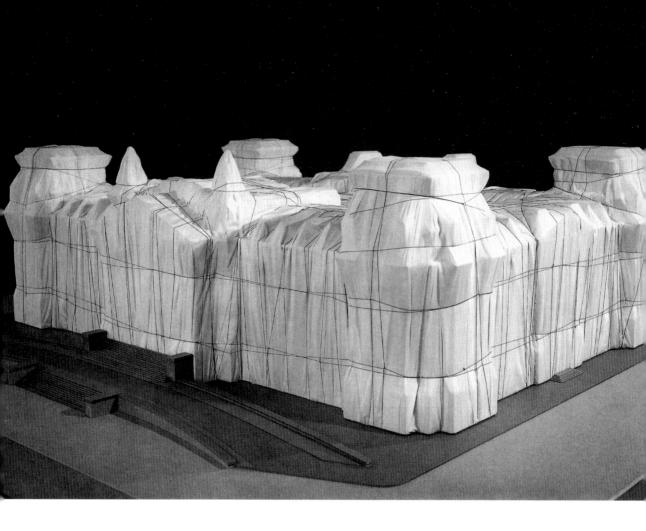

Wrapped Reichstag, Project for Berlin Scale model, 1978 Fabric, twine, wood, cardboard, masonite and paint, 46 x 244 x 152 cm The Lilja Art Fund Foundation

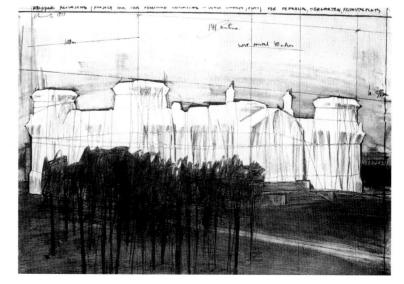

Wrapped Reichstag, Project for Berlin
Collage, 1977
Fabric, twine, pencil, pastel and charcoal,
22 x 28 cm
Hamburg, Collection Estate of G. Bucerius

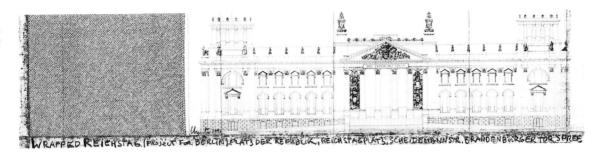

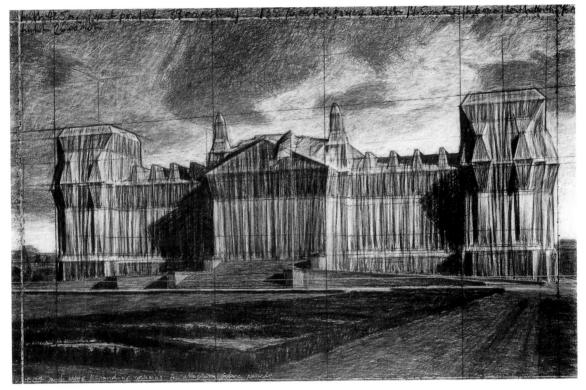

architecture. Although it also manifests elements of antique drapery and folds, the building however still remains intact. The same goes for *The Pont Neuf Wrapped*, *Paris* (1975–1985, p. 65). Even as a work of architecture, the bridge continued to function: boats continued to sail under its wrapped arches, while cars were driving, and pedestrians walking on it.

3) Urbanism and environmental art. The celebrated double project *The Umbrellas, Japan – USA* (1984–1991, p. 70/71), an installation of 3,100 two-storyhigh umbrellas – blue in Japan and yellow in California – spread across areas of 48 kilometers (30 miles) and included elements of urban planning. To undertake the project, the Christos needed permission from the Ministry of Construction in Tokyo, as well as other authorities. The project created house-like structures without walls running along highways and roads, or set along-side schools, temples, gas stations, etc. The Christos can also be regarded as environmental artists in their creation of rural and urban environments, such as the *Running Fence* in California in 1976 (p. 51). After two weeks all sites are restored to their original condition and the materials recycled.

Wrapped Reichstag, Project for Berlin
Drawings, 1994 in two parts
Pencil, charcoal, pastel, wax crayon, techincal
data, map and fabric sample,
38 x 165 cm and 106.6 x 165 cm
Germany, Private collection

"Miserable autumn weekends"

Out of Bulgaria

Christo Vladimiroff Javacheff was born on June 13, 1935, in Gabrovo, an industrial town north of Bulgaria - the very same day and year, amazingly, that Jeanne-Claude was born in Casablanca to a French military family. Christo's father owned a chemical factory which he established in Gabrovo. His mother, Tzveta Dimitrova, who was Secretary General of the Sofia Academy of Fine Arts until her marriage in 1931, had fled Macedonia for Bulgaria following Turkish massacres. "Our mother," Anani, Christo's older brother, told Balkan Magazine (IX, 1993), "had to flee Macedonia with our grandmother in 1913. Grandmother was a troublemaker in Salonika, where she lived. Our grandfather was a big merchant in Salonika - the Turks killed him in 1913, on an island together with other people. My grandmother was left alone, and had three children on her hands: a two-month-old boy and two girls. The house was surrounded by the Turks. She was inside the house together with the children. The Turks brought artillery and started firing on the house. The family survived somehow, escaped death, and on the next day, or God knows after how many days, managed to get on board a British ship that had just arrived. My grandmother was disguised as a Turkish woman, with her three kids and a sewing-machine, which she managed to carry. She finally arrived safely at Dedeagaç, and from there to Sofia. My mother was seven years old then. It was in Sofia that my mother later went to high school."

Christo's family, which included an elder brother, Anani (now a well-known actor in Bulgaria) and a younger brother, Stefan (now a chemist), lived through the Second World War in a relatively secure country house that was a haven for artists and other friends fleeing the Allied bombing of the cities. Christo's childhood memories included the corpses of partisans executed in the streets, and the entrance of the Red Army into Bulgaria in 1944.

Christo's father, a Western-educated scientist, was harassed and hounded by the new Communist regime. His chemical factory was nationalized under the Communists, and the teenaged Christo visited his father, now branded a "saboteur," in prison. To *Balkan Magazine*, Christo recalled the early 1950s as a time of "frenzy and upheaval. Everything slowed down and decadence set in."

By the time he was twelve, Christo had already vaguely heard about the Reichstag, since it played a key role in Bulgarian Communist lore: Georgi Dimitrov, Prime Minister of Bulgaria in the late 1940s, had been a defendant (later acquitted) in the Reichstag fire trial in 1933. Christo himself was a quiet, gentle youngster, shy of girls and vulnerable to ridicule. "I was restless, frantic," remembers Christo's brother Anani, "while he was always at mother's side. He was her favorite one. He always used to tell mother, Tzveta was her name, that they would never part ... she suffered much when developments in Hungary took place, and Christo went over to Prague and later reached

Vladimir Javacheff, the Artist's Father Resting, 1952 Pencil on paper, 24.5 x 18.5 cm

PAGE 10: Self-Portrait, 1951 Pencil on paper, 51.5 x 41.9 cm

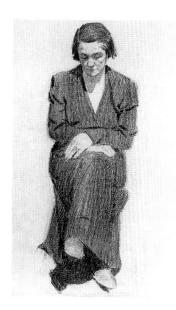

Tzveta, *the Artist's Mother*, 1948 Pencil on paper, 48.5 x 31.5 cm

Vienna." Christo himself recalls the beautiful house in Gabrovo with fondness, and the village, too, where the family used to spend the summer. "The family got acquainted with a village woman who brought us butter and cheese during the war. We became very good friends, and every summer we went over there. We assisted with the household and farm work. We tended the sheep, harvested fruit, and so spent the whole summer."

Christo's earliest ventures in art dated back to that village, too, where "there was a woman who was born without arms. She used to do so many things, almost everything, with her feet. She taught herself to do so – even knitted with her feet. At the age of six, I made her and others sit for me, so I could paint their portraits." In 1953 he began his formal training at the Academy in the Bulgarian capital, Sofia. There he studied painting, sculpture, architecture and design until 1956. Socialist realism was the order of the day, and the agitprop approach prevalent throughout the Communist bloc dictated a propagandist, Marxist-Leninist treatment of subject matter and style in art.

The kinds of grotesque lengths Christo's generation had to go to have often been described. The route of the Orient Express, for instance, lay through Bulgaria; and students were therefore sent to agricultural cooperatives (on "miserable autumn weekends") to advise farmers along the track how to show off their tractors or haystacks to the best advantage, to impress travellers from capitalist countries. This propaganda work was mandatory to obtain course credit. Still, something more valuable in his later life may have remained with Christo from those curious exercises: his communicative skill, and his sense of art's physical dimension in landscape, may derive in part from such experience.

He fell foul of socialist realism, and Professor Panayotov's Academy dictates, with a composition that showed peasants in a cornfield (p. 13), resting instead of working. One was drinking; the soil looked unproductive; and even the violet and green shirts of the peasants met with disapproval. Christo was defying the system. How dare he be so provocative?

Textile Machinery in Plovdiv Factory, 1950 Pencil on paper, 40 x 54 cm

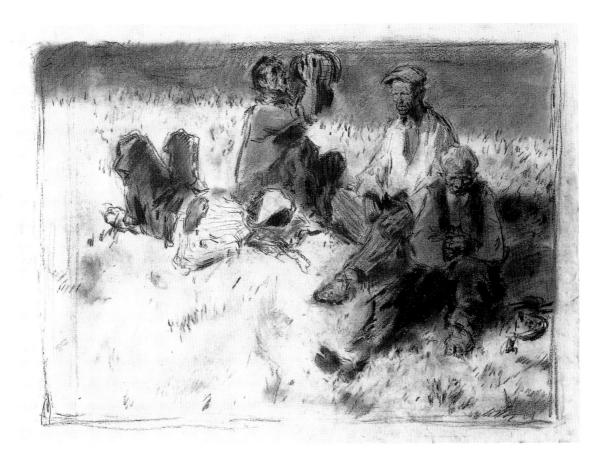

Bulgaria was the most ardently Stalinist nation in the Communist bloc, the isolated hinterland of Europe, and Christo knew that if he were ever to see work by Matisse or Picasso, Klee or Kandinsky, anywhere outside the covers of a book, he would have to go west. His dream was of Paris, but his first stop was Prague, where, for the first time, he saw originals by the great moderns. Then, on January 10, 1956, with eighteen others, Christo bribed a frontier guard on the Czech border, and made good his passage by train to Vienna. With neither money nor any knowledge of the language, Christo took a taxi to the only address he knew in Vienna, that of a friend of his father. The address was thirty-five years old, but the friend still lived there and took Christo in, and the next morning the young Bulgarian hurried off to enroll at the Vienna Academy of Fine Arts. Matriculation as a student bypassed the need to register as a refugee. Fritz Wotruba was head of the Vienna sculpture department, and Robert Anderson was Christo's professor at the academy, but he stayed for one semester only, moving first to Geneva (where he painted portraits of society ladies and children in order to survive) and from there to Paris.

Farmers at Rest in a Field (study for an oil painting), 1954 Charcoal on paper, 35 x 50 cm

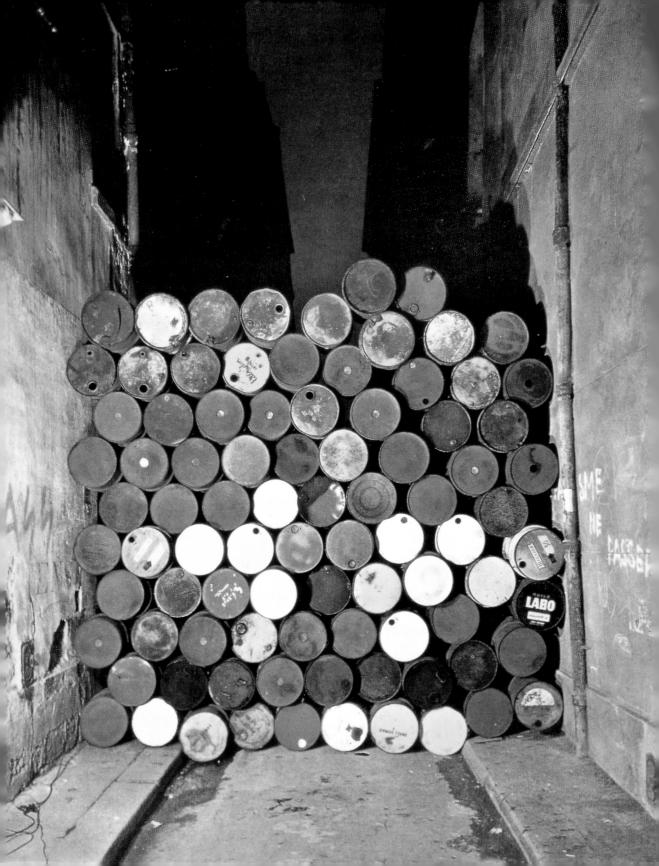

"Revelation through concealment"

Paris

Christo arrived in Paris in March of 1958 and took a tiny room on the Ile Saint-Louis, and, for a studio, a maid's room on Rue de Saint-Sénoch. He continued to make a living painting portraits (signed Javacheff), and his work impressed René Bourgeois, a society hairdresser, who recommended him to the wife of General de Guillebon. De Guillebon was a French war hero who had led the troops that liberated Paris and later taken Berchtesgaden, where Hitler had his Berghof and Adlerhorst retreats. His daughter Jeanne-Claude met Christo when he came to the family home to paint her mother (in three versions - plain Realist, Impressionist, and Cubist) and was soon in love with the penniless Bulgarian refugee. Her family considered him gifted but an unsuitable match: "they wanted Christo as a son, not a son-in-law," Jeanne-Claude told Avenue Magazine in 1990. But she and Christo were soon living together and later married, with Christo's friend Pierre Restany, the critic and founder of the Nouveaux Réalistes movement, acting as best man at the wedding. "I could tell you it was the art," Jeanne-Claude told Avenue, "but actually he was a hell of a lover."

Christo's move west had been a serious upheaval in his life, one he had countenanced because conditions in which creative work had to operate behind the Iron Curtain were stifling. In choosing the freedom every artist needs, he was not without personal courage; but finding out what it was he had to do (as he himself puts it), locating his authentic vein and genuine self, mattered above all else. In Paris he now took two further steps that changed his life as an artist.

The first was simple: he shed his Slavic surname, Javacheff, and henceforth used only his first name, Christo, the name by which he is now known worldwide, for his art.

The second change, dating almost from the beginning of his time in Paris, touched upon the substance of his art. He began to use fabric. Christo wrapped cans, bottles, chairs, a car – anything he could find, everyday objects of no particular beauty or interest. Resembling the Pop artists in this respect (and also, later, in his skillful use of press and the media for his own purposes), he implicitly assumed that any object could be worthy of the attentions of art: there were no hierarchies or distinctions any more. He wrapped his chosen objects in canvas and tied them securely with string, rope, or twine. He even painted some of them.

Over the next few years he continued to wrap a bewildering variety of objects – chairs, a wheelbarrow, a motorcycle, naked women, oil barrels (of which we shall have more to say), and a Volkswagen car. On occasion he juxtaposed items: *Wrapped Cans and Bottles* (1958–1959) included several wrapped bottles and cans alongside a few unwrapped paint cans, and bottles containing pigment.

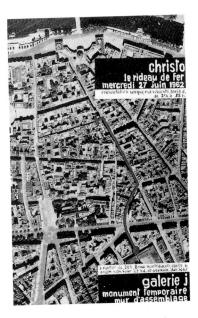

Invitation card for Wall of Oil Barrels – Iron Curtain (Le Rideau de Fer), 1962 New York, Collection Jacob Baal-Teshuva

PAGE 14: Wall of Oil Barrels – Iron Curtain, Rue Visconti, Paris, June 27, 1962 240 oil barrels, 4.3 x 3.8 x 1.7 m

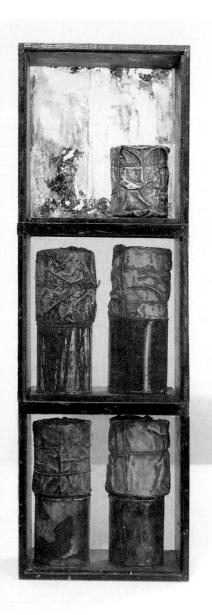

Shelves, 1958
Five wrapped cans and four cans on three shelves: wood, glass, lacquered canvas, rope and paint, 90 x 30 x 18 cm

PAGE 17: Wrapped Oil Barrels, 1958–1959
Fabric, enamel paint, steel wire and barrels
Barrels range in size from: 49 x 33 cm to
89 x 59 cm

The wrapping of small objects that could be transformed into limited editions for a collectors' market was to be of considerable importance in Christo's future career, since it became an important source of income and thus of the funding needed for projects that became ever larger and costlier. Thus in the 1960s there were editions of wrapped magazines (p. 24); of a Wrapped Flower (it was presented to George Maciunas as a gift); of Wrapped Roses (in 1968, on the occasion of Christo's exhibition at the Institute of Contemporary Art in Philadelphia, to help cover expenses incurred by his mastaba there and, in the same year, an edition from Richard Feigen Graphics in New York); a Wrapped Painting in 1969; a wrapped model of the Cologne cathedral, done by German artist Klaus Staeck in 1969 and signed by Christo on the sticker; prints of wrapped trees in 1970 (the first life-size Wrapped Tree dating from 1966 in Holland); and so forth. Occasionally, these small-scale objects have been given away for purposes of good relations, but more usually they have attracted collectors who want lasting mementoes, and have also played a part, however indirect, in making Christo's larger-scale projects possible.

The principle of wrapping, covering, and concealing (yet not entirely disguising) allowed for surprising versatility. Works such as the *Package on Table* (1961, p. 23), *Wrapped Chair* (1961) or *Wrapped Motorcycle* (1962) might be clad in semi-transparent materials instead of (or in addition to) opaque fabric. Objects might be only partially masked; or, of course, they might be entirely enveloped so that the content was neither visible nor recognizable (*Package*, 1961, p. 23). For the principle at stake in this process, witless to hostile critics and enchanting in the eyes of Christo's supporters, David Bourdon found the perfect formula, in a biography published in 1970: "revelation through concealment".

That is indeed the key. Christo and Jeanne-Claude touch the world with wonder. From those modest beginnings in Paris they have gone on, over a career of fourty-three years, to wrap everything – from tin cans to a stretch of Australian coastline – and have created a body of work that, as we shall see, has gone far beyond wrapping, retaining only the use of fabric as a common denominator. Their work has afforded "one of the eeriest visual spectacles of our time" (Bourdon), and has made the Christos celebrities on the international stage. Not that fame in itself is of interest: but theirs is the reward for an unusual steadiness of vision.

During Christo's French years, the Paris art scene was dominated by the Nouveaux Réalistes, the group of New Realists founded in 1960 by Pierre Restany. Christo's membership to this group is sometimes disputed, even by the artist himself. The eight founding members of the group, signatories to the original manifesto, were Yves Klein, Martial Raysse, François Dufrêne, Raymond Hains, Jacques de la Villeglé, Jean Tinguely, Arman and Daniel Spoerri. Others who subsequently became associated with the group - Gérard Deschamps, Mimmo Rotella, Niki de Saint-Phalle. César, and Christo himself - never in fact signed the Paris Manifesto. Though he was not formally invited to join, Christo exhibited at the group's 1963 show in Munich, and later in Milan. Pierre Restany has claimed that this signalled his membership. Christo denies that this was so, and Bourdon noted that Christo's "involvement was marginal and brief". He indeed exhibited with the group at a much later date, in Nice (July - September 1981) and at the Musée d'Art Moderne de la Ville de Paris (May - September 1986). Although Christo has also exhibited with a variety of other groups, he is now widely considered to be one of the thirteen members of the Nouveaux Rèalistes - erroneously according to the Christos.

In 1961 he had his first one-person show at the Haro Lauhus Gallery in Cologne, where he exhibited his first outdoor barrel structures. At that time,

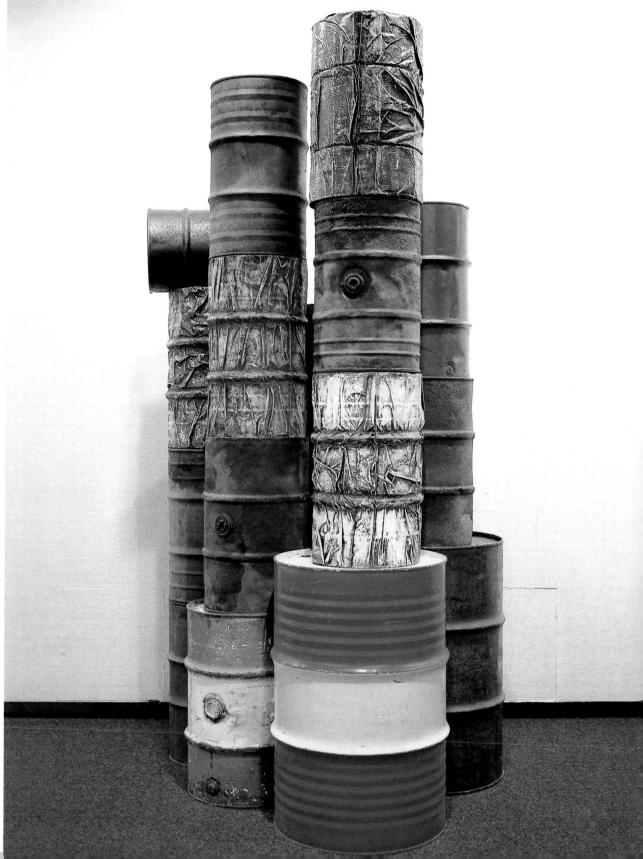

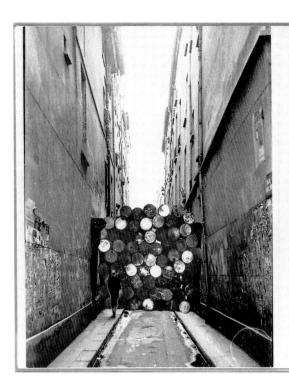

PROJET DU MUR PROVISOIRE DE TONNEAUX METALLIQUES (Rue Visconti, Paris 6)

Entre la rue Bonaparte et la rue de Seine, la rue Visconti, à sens unique, longue de 140 m., a une largeur moyenne de 3m. Elle se termine au numéro 25 à gauche et au 26 à droite.

Elle coente peu de commerces: une licruirie, une galerie d'art moderme, un antiquaire, un magnain d'électricité, une épicerie... "À l'an gle de la rue Viscouti et de la rue de Seine le cabaret du Petit More (ou Maure) a été ouvert en 1618. Le poète de Saint-Amant qui le fréquantait assaidment y mourut. Le galerie de peinture qui remplace la taverne a neureusement conservé la façade, la grille et l'enseigne du XVII Bme. siècle" (p.134, Socnegue/Ciécert - Promensie dans les rues de Paris, Kive gauche, écution benoêt).

Le Mur sera élevé entre les numéros l et 2, fersara cospletement la rue à circulation, coupera toute communication entre la rue Bonaparte et la rue de Seine.

Exclusivement construit avec les tonneaux métalliques destinés au transport de l'essence et de l'unile pour voitures, (estampillés de marques diverses: ESSO, AZUR, SHELL, BP et d'une contennes de 50 l. ou de 200 l.) le Bur, haut de 4 m., a une largeur de 2,90 m. 8 tonneaux couchés de 50 l., ou 5 tonneaux de 200 l., en constituent la base. 150 tonneaux de 50 l., ou 80 tonneaux de 200 l. sont necessaires à l'éxécution du Mur.

Ce "rideau de fer" peut s'utiliser comme barrage durant une période de travaux publiques, ou servir à transformer définitivement une rue en impasse. Enfin son principe peut s'étendre à tout un quartier, voir à une cité mandéme entière.

> CHRISTO Paris, Octobre 1961

Project for a Temporary Wall of oil Barrels, Rue Visconti, Paris

Collage, 1961

Two photographs and a typewritten text, 24 x 40.5 cm

"Rue Visconti is a one-way street, between Rue Bonaparte and Rue de Seine, 140 meters long and with an average width of 3 meters. The street ends at number 25 on the left side and at 26 on the right. It has few shops: a bookstore, a modern art gallery, an antiques shop, an electrical supplies shop and a grocery store. At the corner of Rue Visconti and Rue de Seine, the Cabaret du Petit More (or Maure) was opened in 1618. The poet Saint-Amant, an assiduous customer, died there. The art gallery that now stands on the site of the tavern has fortunately retained the façade and the seventeenth-century sign, as described on page 134 of Rocheguide/Clébert: Promenades dans les rues de Paris, Rive Gauche, Editions Denoël. The Wall will be built between numbers 1 and 2, completely closing the street to traffic, and will cut all communication between Rue Bonaparte and Rue de Seine. [...] This Iron Curtain can be used as a barricade during a period of public work in the street, or to transform the street into a dead end. Finally, its principle can be extended to a whole area or an entire city. CHRISTO, Paris, October 1961"

Cologne was already developing the lively art scene for which it is now known, and Christo met John Cage, Nam June Paik and Mary Bauermeister there, as well as his first collector, industrialist Dieter Rosenkranz. The *Dock-side Packages* (1961, p. 20) and *Stacked Oil Barrels* were created in and for Cologne parallel to his exhibition. The former, on the Cologne riverfront, consisted of several heaps of cardboard barrels and industrial paper rolls covered with tarpaulins and secured with rope; the latter was precisely described by its title (the barrels lying on their sides, as he had previously done in Paris). Both works were made by simply rearranging material already available at Cologne's Rhine docks. It was the Christos' first collaboration.

David Bourdon remarked in his biography of Christo that the large assemblages of oil drums he erected along the Cologne waterfront were hardly distinguishable from the stockpiles that are found in harbors everywhere – but Christo had in fact composed his materials, and had used hoists, cranes and tractors to arrange them as he required. This touches upon the very heart of what is sometimes seen as a minimalist element in the Christos' artistic approach. Traditionally, artists declare themselves free both in their selection from given reality and in their skill at handling their chosen material; the Christos, throughout their careers, have always challenged this conception, by their great readiness to accept what is given and subject it to little alteration.

1961 was also, of course, the year in which, on August 13, the Wall was built by East Berlin's Communist regime. A stateless man with no passport, himself a refugee from a Communist country, Christo was deeply affected and angered by the East German move. On his return to Paris from Cologne, in October 1961, he began preparing his personal response to the building of the wall. This was the *Wall of Oil Barrels – Iron Curtain* (1961–1962, p. 14); the Christos proposed to block Rue Visconti, a narrow one-way street on the Left

Project for a Wrapped Public Building, 1961 Collaged photographs by Harry Shunk and text by Christo, 41.5 x 25 cm

"I. General Notes:

The building is in a huge symmetrical site. A building with a rectangular base, without a façade. The building will be completely closed - that is, wrapped on all sides. Access will be underground, with entrances placed at 15 or 20 meters from the building. The wrapping of the building will be performed with sheets of tarpaulin and sheets of reinforced plastic of an average width of 10 to 20 meters, and with metal cables and ordinary ropes. With the cables we can obtain the points which can then be used to wrap the building. The cables make scaffolding unnecessary. To obtain the required result, some 10,000 meters of tarpaulin, 20,000 meters of cable and 80,000 meters of rope will be needed. This project for a wrapped public building can be used: I. As a sports hall with swimming pools, football stadium and Olympic stadium or as a skating or ice-hockey rink. II. As a concert hall, planetarium, conference

hall or as an experimental testing site. III. As a historical museum, or as a museum of art ancient or modern.

IV. As a parliamentary hall or as a prison. CHRISTO

October 1961, Paris"

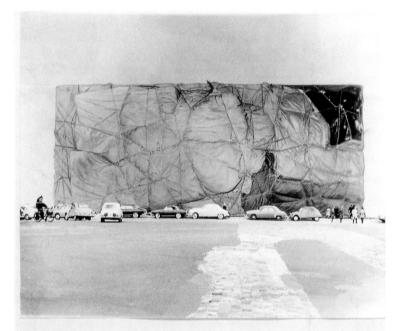

PROJET DM UN EDIFICE PUBLIC EMPAQUETE

I. Notes générales: Il s'agit d'un inseuble situé dans un emple-cement vaste et régulier, Un bâtisent ayant une base roctengulaire, sans anoune façade Le Ditient sur completement fermé-c'est à dire empaqueté de tous les co-tés. Les entrées seront souterraines, placée environ à 15 ou 20 metres de cet édifice. L'empaquetage de oct immeuble sere déceuté avec des baches des tolles gommées et des tolles de matiere plastique renforcée d'un largeur mouenne de IO à 20 metres, des cordes métalliques et ordinaires. Avec les de métal nous pouvons obtenir les points, qui peuvent servir en suite à l'empaquetage de battment. Les cordes métalliques évitent la construction d'un échafaudage. Pour obte-nir le resultat nécessaire il faut environ 10000 metres de baches, 20000 metres de cordes métalliques, 80000 metres de cordes ordinaires. ordinaires. Le present projet pour un edifice public empaqueté est utilisable: I.Comme salle aportive-avec des piscines,

I. Comme calle sportive avec des piscines, le stade de football, le stade des disci-plines olimpiques, ou soit comme patinoire à glace ou à hockey. Il comme patinoire l'I. Comme salle de concert, planetarium, sa-lle de conférence et essais expérimentaux. III. Comme un musée historique, d'art anci-éne et d'art moderne. IV. Comme salle parlementaire ou un prison.

CHRISTO octobre 1961, Paris

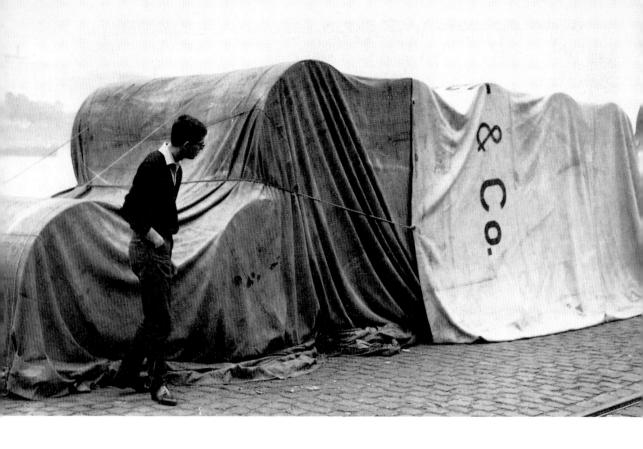

Christo standing in front of *Dockside Packages*, *Cologne Harbor*, 1961

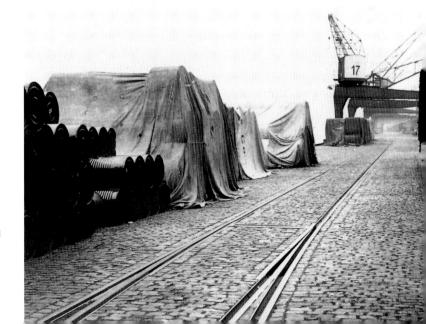

Dockside Packages, Cologne Harbor, 1961 (detail)
Rolls of paper, tarpaulin and rope,
480 x 180 x 960 cm

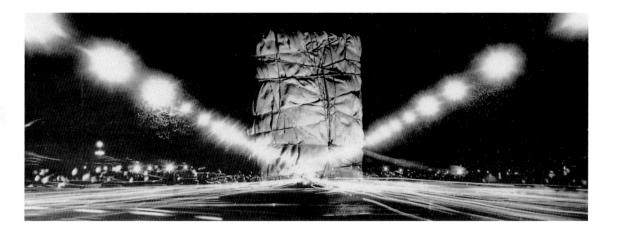

Bank, with 240 oil barrels, and prepared a detailed description of the project (p. 18).

The preparation of written documentation, accompanied by photocollages and logistical analysis, has become ever more complex over the years as the Christos' projects have become more demanding and ambitious, but the purposes served by these documents have remained essentially constant: to persuade the relevant authorities to give permission for a project to proceed, to publicize and define the nature of a project, and, as commentators have pointed out, to draw the critics' attention towards the examination of technical, social or environmental data. In the case of the *Wall of Oil Barrels – The Iron Curtain* project the document failed in its first purpose: permission was refused. (Years later, in New York, when the Christos proposed to close 53rd Street with 441 barrels to mark the end of the Dada and Surrealism exhibition at the Museum of Modern Art on June 8, 1968, they were again out of luck: various city authorities refused to grant them the necessary permission.)

Undeterred, the Christos went ahead with their *Wall of Oil Barrels – The Iron Curtain* project without permission. For eight hours on June 27, 1962, they blocked the Rue Visconti – at various times the home of Racine, Delacroix and Balzac – with 240 oil drums. Christo carried every one himself; the armies of helpers, both professional and unskilled, who were to become so familiar a feature of the spectacular art projects in later years were conspicuous by their absence on this occasion. The barricade, measuring 4.3 by 3.8 by 1.7 meters, obstructed the traffic as predicted. The oil barrels were left in their found state, in their industrial colors, complete with brand names and rust.

The Christos were inevitably summoned to the police station to answer for the obstruction, but no case was ever pursued. Whether the barricade was understood by casual passers-by to refer to the Berlin Wall is a debatable point; at that time there were frequent demonstrations in Paris in protest against the Algerian war, and permission may even have been refused because officials mistook the project for a protest on that issue. But the Christos had made a breakthrough nonetheless in terms of public art, by using a street, oil barrels, and even the presence of people in the street – given features never previously considered admissible in art – to create a temporary work. Crucial to the Christos' post-modern approach to art has always been this emphasis on the temporary.

Wrapped Building, Project (detail), 1963 Photomontage

Man Ray

The Enigma of Isidore Ducasse, 1920

Photograph

Paris, Collection Lucien Treillard

Henry Moore *Crowd Looking at a Tied-up Object*, 1942 Chalk, wax crayon, watercolor, pen and ink on paper, 43.2 x 55.9 cm Collection The Late Lord Clark of Saltwood. Courtesy the Henry Moore Foundation

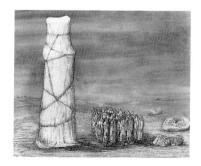

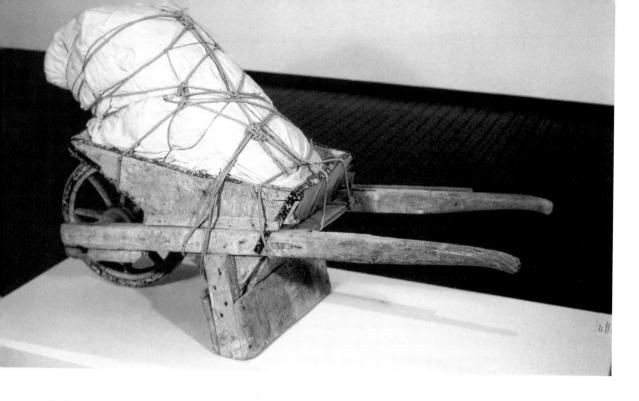

Package on Wheelbarrow, 1963 Cloth, wood, rope, metal and wooden wheelbarrow, 89 x 152.5 x 58.5 cm New York, The Museum of Modem Art

PAGE 25 LEFT:

Package on Table, 1961 Wood, fabric and ropes, 124 x 61.5 x 30 cm

PAGE 25 RIGHT:

Wrapped Road Signs, 1963

Wooden road signs, steel stand, lantern, chain, fabric, rope and jute, 181 x 62.5 x 47 cm Künzelsau, Museum Würth

PAGE 25 BOTTOM:

Package, 1961

Fabric and rope on wood, 84 x 137 x 20.3 cm New York, The Museum of Modern Art

Christo's ambition extended to large-scale projects at a very early date. In 1961 he made his first study for a Wrapped Public Building (p. 19), collaging photographs and preparing a written account: "The building is in a huge symmetrical site. A building with a rectangular base, without a façade. The building will be completely closed - that is, wrapped on all sides. Access will be underground, with entrances placed at 15 or 20 meters from the building. The wrapping of the building will be performed with sheets of tarpaulin and sheets of reinforced plastic of an average width of 10 to 20 meters, and with metal cables and ordinary ropes." Soon Christo was making his first proposals to wrap specific public buildings - the Ecole Militaire in Paris, and the Arc de Triomphe - but none of these projects was ever realized. The wrapping of the Ecole Militaire was to involve covering the building with tarpaulins, using steel cables and strong manila rope. (The steel cables would obviate the need for scaffolding.) The wrapping (Christo explained in his project description) could be used as protection during maintenance work such as repair or cleaning of walls; for a parliament or a jail; or as package scaffolding if the building were ever to be demolished. The wariness of the authorities in the face of such proposals was plainly connected with an inability to decide how seriously to take the artist.

There are few precedents for Christo's interest in wrapping. Henry Moore's drawing *Crowd Looking at a Tied-up Object* (1942, p. 21) and Man Ray's photograph *The Enigma of Isidore Ducasse* (1920, p. 21), showing a wrapped sewing-machine, have been suggested as influences, but Christo replies that he did not discover these works until later in his career, after he had begun wrapping.

The issue scarcely seems pressing: even if we accept an affinity between aspects of Christo's work and the two earlier pieces, Christo has in any case long since moved beyond his legendary status in the press as "King of the

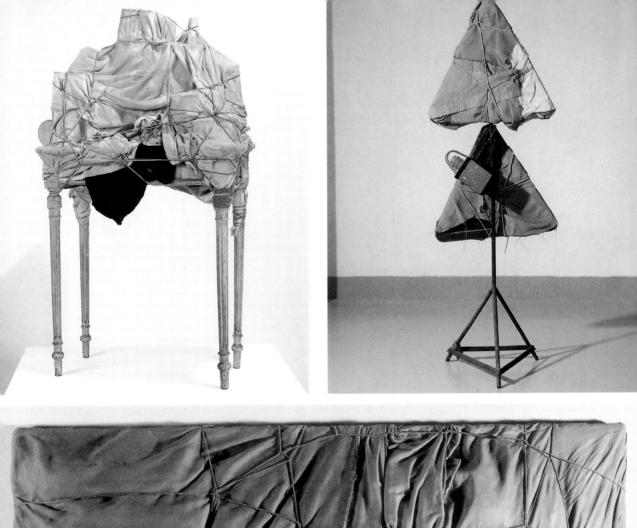

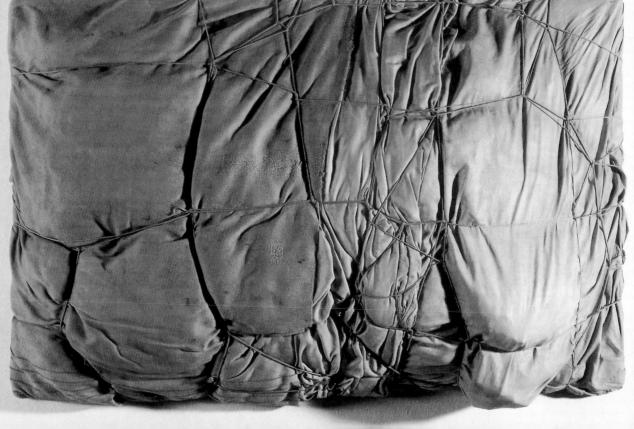

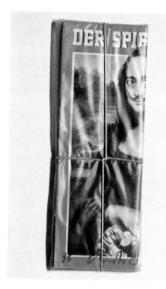

Der Spiegel Magazine Wrapped, 1963 Magazine, polyethylene and rope, 30 x 13 x 2.5 cm New York, Collection Jeanne-Claude Christo

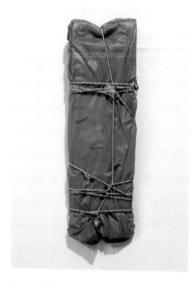

Wrapped Magazine, 1963
Magazine, polyethylene and rope,
40 x 13 x 3.5 cm
New York, Collection Samuel and Ronnie
Heyman

PAGE 25:

Wrapped Portrait of Jeanne-Claude, 1963 Oil painting wrapped in polyethylene and rope, 75 x 55 x 4 cm Wrap," and many of the Christos' important later projects – the *Valley Curtain, Rifle, Colorado* (1970–1972, p. 38) or *Running Fence* (1972–1976, p. 49), the *Surrounded Islands* (1980–1983, p. 54) or *The Umbrellas, Japan – USA* (1984–1991, p. 70/71) – merely retain the interest in using fabric.

In *The Gates* and *Over the River*, two current projects looking beyond the Reichstag wrapping, the emphasis is not on wrapping but on enhancement, on the creation of new shapes and images using the natural environment together with effects of fabric, motion and light.

The Christos' esthetic, as told to the present writer, is a distinctive one: "Traditional sculpture creates its own space. We take a space not belonging to sculpture, and make sculpture out of it.

It's similar to what Claude Monet did with the cathedral at Rouen. Claude Monet was not saying that the Gothic cathedral was good or bad, but he could see the cathedral in blue, yellow and purple."

In evolving this esthetic, the Christos have invested immense resources of energy, resources directed (as we have seen) at locating their genuine selves. Much of this energy has to do with their displaced status; it is no accident that they have made their home in the great melting-pot New York. "In 1964," Christo told *Balkan Magazine*, "I already knew I had to go to America because over there things were already evolving. As early as 1962 in Paris, the famous art dealer Leo Castelli told me my place was in New York." As they kept moving, the Christos were forever seeking, and forever finding.

And what they found, above all else, was a means of creation that satisfied the wise dictum of G. K. Chesterton: "Every work of art has one indispensable mark: the center of it is simple, however much the fulfilment may be complicated." Critics well or ill disposed whose concern is with the logistics of the Christos' art would do well to bear this in mind.

Esthetically speaking, one other issue needs addressing, since the Christos' reliance on the beauties of a creation with no meanings beyond the thing itself implies an indifference to conceptions that see art as having a role (social, political, moral or philosophical) beyond itself. Or, to put it differently: if the Christos are content for the artwork to "be" rather than to "mean," does that not place them in the art-for-art's-sake camp? The notion of art for art's sake, originated by the French writer Victor Cousin (1792–1867), has fallen into disrepute in recent decades, since it implies a narcissistic disdain for life as it is lived and experienced by most people.

The doctrine is associated with the priestly caste of artists, writers and thinkers of the later nineteenth and early twentieth centuries (such as Mallarmé or Nietzsche, Gustave Moreau or Stefan George) who held themselves aloof from common life and tended to have right-wing political ideas that in some cases (Ezra Pound) did not even stop short of fascism. If it is correct to see the Christos as sharing some of the art-for-art's-sake convictions, it is also important to point out that their brand of populism always insists on the pleasure of ordinary people, rather than excluding them: the implications of art for art's sake are complex, and we should beware of suggesting that Christo and Jeanne-Claude endorse any of them except the love of beauty in the artwork, regardless of social, moral, or other affiliations.

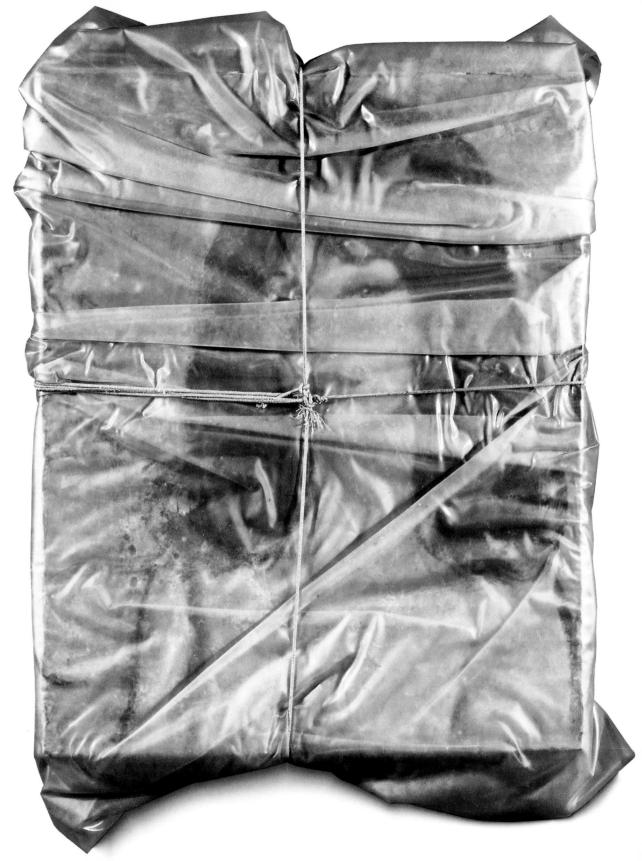

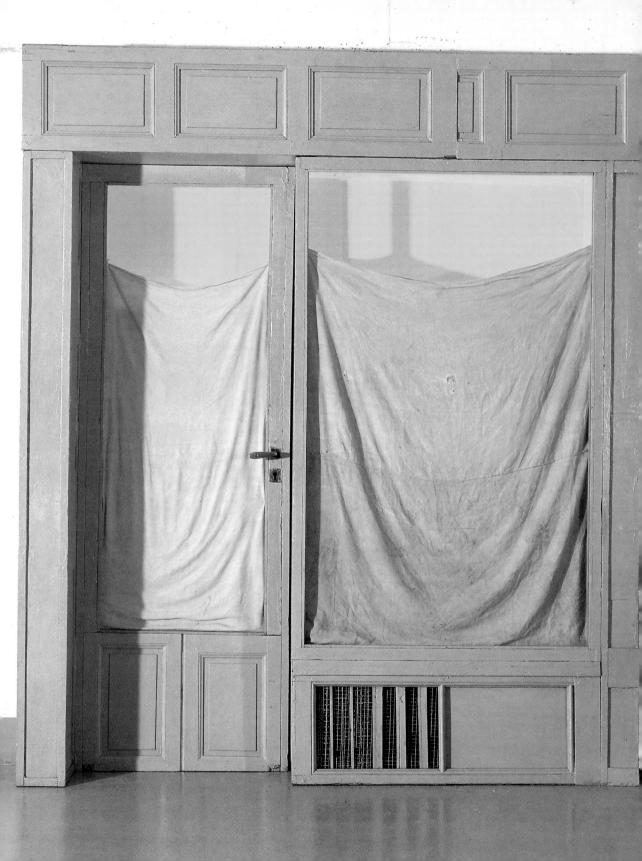

"Tributes to artistic freedom"

Store Fronts, Air Packages, Wrapped Museums

1964 marked another new beginning in their life, as Christo, Jeanne-Claude and their four-year-old son Cyril made the move Castelli had urged, the move to the city that had now superseded Paris as the world's art capital: New York. They first stayed at the Chelsea Hotel, the famed home-from-home for artists, writers and composers.

Before long, Christo and Jeanne-Claude were living in a downtown loft, which they fixed with money borrowed from an old friend. As collateral for their bill at the Chelsea they left the owner, Stanley Bard, one of the Store Front projects Christo had created in New York. The debt was cleared in eight months, but the work remained at the Chelsea on loan, and in due course, some twenty years later, the Christos and the hotel proprietor agreed to donate it to the Israel Museum in Jerusalem.

The Store Fronts, the first of which Christo built at the Chelsea, were shop façades made of wood and painted in a variety of colors - each project preceded by preparatory drawings and collages. They can be seen as a continuation of the glass show-cases made in Paris in 1963 before his departure for New York. Christo used fabric or wrapping paper (or both) to mask the inside of the display windows and glass doors; at times an electric light was placed inside. The result was enigmatic, architectonically elusive, evocative: the Store Fronts were of great beauty, possessed of a quiet melancholy and a sense of loneliness that recalled the work of the American painter Edward Hopper, or the boxes of Joseph Cornell. Their pervasive sense of mystery left the observer wondering what was behind the façades. The materials Christo used were plexiglass, old doors and wood found on the street, and, later, galvanized metal and aluminum. The Green Store Front has been exhibited in 1964 at Leo Castelli's Gallery in New York (now in the collection of the Hirshhorm Museum in Washington D. C.), and other storefronts were seen in the Stedelijk van Abbe Museum at Eindhoven in Holland. Christo continued these works for four years, and his largest, Corridor Store Front, was exhibited at Germany's documenta IV show in Kassel in 1968.

During the same period in the mid–1960s, the Christos were making their three *Air Packages*, one of them being the largest inflated structure ever created without a support structure. The first was done for Christo's Eindhoven exhibition, and measured 5 meters in diameter. It was made of polyethylene, rubberized canvas, rope, steel cables – and, of course, air. The second, measuring 1,200 cubic meters, was made at the Minneapolis School of Art in October 1966 by Christo and Jeanne-Claude with the assistance of 147 students (p. 31).

The core of the air package consisted of four high-altitude research balloons from the US Army, independently sealed, each measuring about 550 centimeters in height and 762 centimeters in diameter. There were also 2,800

Show Window, 1965 Galvanized metal, Plexiglas and fabric, 213.5 x 122 x 9.5 cm

PAGE 26: **Purple Store Front,** 1964 Wood, metal, enamel paint, fabric, plexiglas, paper and electric light, 235 x 220 x 35.3 cm

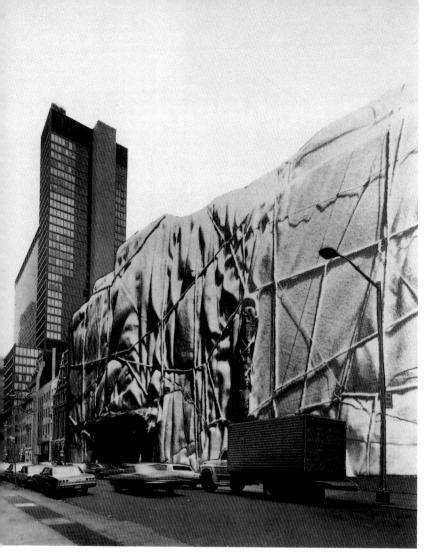

The Museum of Modern Art Wrapped, Project for New York

Collaged photographs (detail), 1968 38 x 25.4 cm

New York, The Museum of Modern Art, gift of Mrs Dominique de Menil

Wrapped Whitney Museum of American Art, Project for New York

Scale model, 1967

Fabric, twine, rope, polyethylene, wood and paint, 51 x 49.5 x 56 cm

Künzelsau, Museum Würth

colored balloons of an average 70 centimeters in diameter. All the balloons were inflated, sealed, and then wrapped in 740 square meters of clear polyethylene, which was in turn sealed with Mylar tape and secured with 950 meters of manila rope. The resulting oblong package was further inflated by two air blowers.

Due to air turbulence, the Aviation Agency vetoed the planned airlift, and the helicopter was permitted to lift the air package no more than 6 meters off the ground. The use of this helicopter was funded by Helen and David Johnson, collectors and friends of the Christos, in exchange for an original drawing. The remaining costs of the project were covered by an edition of one hundred *Wrapped Boxes*, which (in contrast to Christo's customary works) exactly resembled ordinary parcels. These were mailed to members of the Contemporary Arts Group, and those who inadvertently opened the boxes found inside a signed and numbered certificate reading: "You have just destroyed a work of art." In such gestures, Christo was wholly in line with the provocative, situationist mood of much progressive art in the mid–1960s.

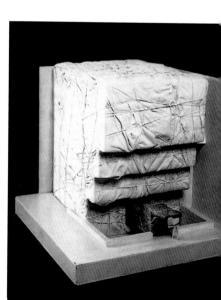

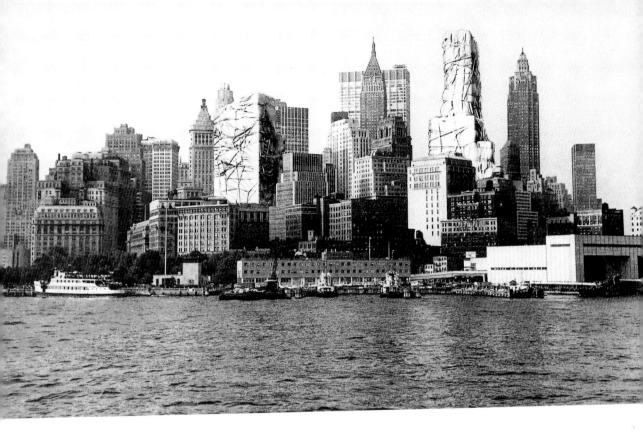

The third Air Package (1967-1968, p. 33), titled 5,600 Cubic Meter Package, which attracted the widest public attention, weighed in at 6,350 kilograms and consisted of an envelope of 2,000 square meters of trevira tied with rope. The heat-sealed envelope was contained in a net of 3.5 kilometers of rope prepared by professional riggers and secured with 1,200 knots. Other statistics might be added: the Christos' work invites analysis in terms of figures, and an account that failed to mention the variable-speed centrifugal blower used to maintain air pressure, or the gasoline-powered generator kept on stand-by in case of power failure, would arguably have omitted something of significance. After all, one of the keys to the Christos' importance is their insistence on redefining the terms in which artworks are approached and assessed. There is inevitably something absurd in this; critics of Leonardo, Rembrandt or van Gogh do not spend any more of their time than they can help on the measurements of the canvas, the composition of pigments, or the number of people it would require to hang a painting on a gallery wall. But then, these things are incidental to an understanding of art in the past, whereas the Christos, creating the esthetic climate in which their work can be understood and enjoyed, implicitly insist that statistics are essential to their projects - and in this they are routinely abetted by the critics. Comparison with rock music, and with much more in a post-modern world of art and entertainment, is inevitable: discussion of rock quickly includes production values, and subject or content have come to be considered as secondary to the impact of style.

Under the supervision of Christo, Jeanne-Claude, and their friend, chief engineer Dimiter Zagoroff, the Kassel air package was hoisted by two immense cranes from its repose position into its vertical position in the air. After three

Lower Manhattan Wrapped Buildings, Project for No. 2 Broadway and No. 20 Exchange Place

Photomontage (detail from collage), 1964–1966, 52 x 75 cm New York, Private collection

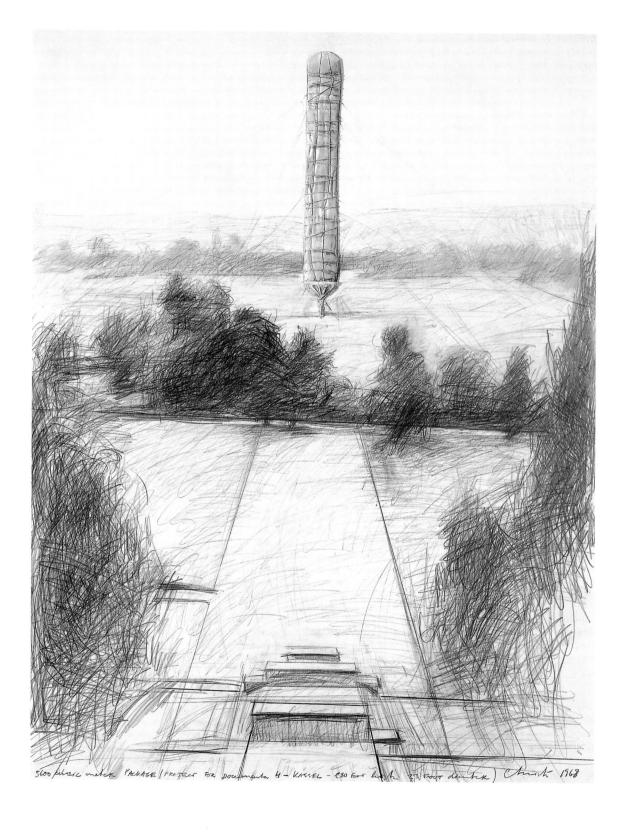

unsuccessful attempts, the *Air Package* was erected (doubtless the "mot juste") between four in the morning and two in the afternoon on August 3, 1968 at that year's Kassel *documenta IV* and became one of that exhibition's most hotly discussed features (p. 33). It remained in place for two months in Karlsaue Park, in front of the Orangerie.

The Christos' work was winning an international following, especially in Europe. In 1968, in connection with the Festival of Two Worlds at the small mountain town of Spoleto in Italy, they proposed wrapping the eighteenth-century Teatro Nuovo, a three-story opera house, but were unable to obtain the necessary permission because of fire regulations. Instead, they were permitted to wrap a 25-meter medieval tower and a baroque fountain in Spoleto's market place (p. 34). It was wrapped under the supervision of Jeanne-Claude, with the help of a team of Italian building workers, while Christo was in Switzerland working on the *Wrapped Kunsthalle*, *Bern*. The work remained in place for three weeks, throughout the Spoleto Festival, and a collaged lithograph was subsequently published.

Much of their success in persuading wary authorities to grant the necessary permissions can be traced directly to their genius for their communicating. "No artists in history," Albert Elsen has observed some years later, "have spent as much time introducing themselves and their art to people around the world as the Christos. The success of their projects with the public in Switzerland, West Germany, Australia, Italy, France, Japan, the United States and elsewhere is due, in no small part, to their accessibility and natural gifts as teachers. They were the first artists to voluntarily conduct human as well as environmental impact reports for their projects. Most artists feel that having to educate the public directly takes too much time away from their own work. For Christo and Jeanne-Claude, verbal interaction with the public is a genuine part of their creativity."

The first European museum to be wrapped by the artists, and indeed the first building anywhere to be wrapped in its entirety, was the Kunsthalle in the Swiss capital, Berne (1968, p. 35). Their project, marking the museum's fiftieth anniversary celebrations, was one of twelve by invited environmental artists. Christo wrapped the building in 2,500 square meters of reinforced polyethylene material, and as usual secured it with some 3,000 meters of rope. Eleven workers took six days to complete the wrapping; an opening in the fabric allowed the continued use of the museum entrance throughout the week the building remained wrapped (one of the briefest projects).

A number of similar projects had not yet come to fruition but helped confirm the growing popular perception of the Christos as leading and innovative artists of their time. One would have involved skyscrapers on Wall Street; another, the National Gallery of Modern Art in Rome; still another, the Allied Chemical Tower (p. 1) in Times Square, (the former NY Times building). In this last case, the project proceeded as far as talks with the company, but in the end came to nothing. Two further museum wraps also had fallen through: first, the Whitney Museum of American Art in New York (abandoned when the well-disposed curator left the museum); and then the Museum of Modern Art in New York (p. 28). In both cases, collages and scale models were prepared, and in the event MOMA – which backed out because wrapping would have increased its insurance premium – held an exhibition of Christo's drawings, collages, and scale models for this and other projects for MOMA in June 1968.

But one further museum wrapping did occur. Visiting the Museum of Contemporary Art in Chicago to discuss a proposed exhibition of their Projects for wrapped buildings, the Christos were offered the opportunity to wrap the museum by its director Jan van der Marck. "If any building ever needed

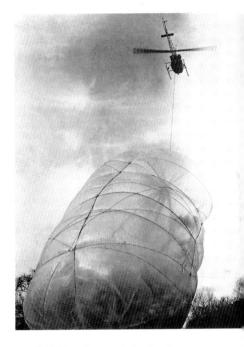

1,200 Cubic Meter Package, during elevation, 1966 Minneapolis, Minneapolis School of Art

5,600 Cubic Meter Package, Project for Kassel
Collage, 1968
Pencil, fabric and twine, 71 x 56 cm

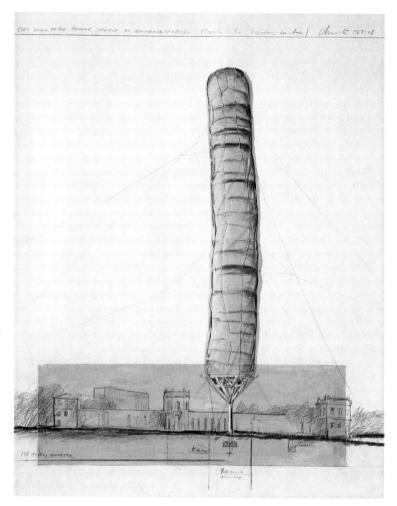

5,600 Cubic Meter Package, Project for documenta IV, Kassel
Collage, 1967–1968
Pencil, coated fabric, twine, tracing paper, charcoal, wax crayon and cardboard,
71 x 56 cm
Berlin, Collection Mr. and Mrs. Roland
Specker

wrapping, it was Chicago's Museum of Contemporary Art," David Bourdon later noted, "a banal, one-story edifice (with a below-ground gallery) having about as much architectural charm as a shoe-box." Wrapping began on January 15, 1969, with students from the Art Institute of Chicago helping for two days as the building was shrouded in 1,000 square meters of heavy tarpaulin with 1,200 meters of manila rope. All the building's entrances and exits remained open, and small openings were cut to keep its air vents free. The public took the result for a construction site, and the Christos, and the Museum director were widely criticized; Sherman E. Lee, for instance, Director of the Cleveland Museum, Ohio, described the wrapping as a "catastrophe." The Age of '68 was of course a period when perceived liberalism and perceived conservatism gladly went to war over issues of esthetics, and their project doubtless provided a welcome pretext. The chief of the Chicago Fire Department ordered the Museum to dismantle the material within forty-eight hours, but the order was not enforced. Meanwhile, the Christos also wrapped the 260 square meters of floor and stairway in the museum's lower gallery (cleared of paintings for the purpose), a new departure in their work (p. 37).

PAGE 33: 5,600 Cubic Meter Package, Kassel, 1967–1968 Coated fabric, rope, steel and air 85 x 10 m

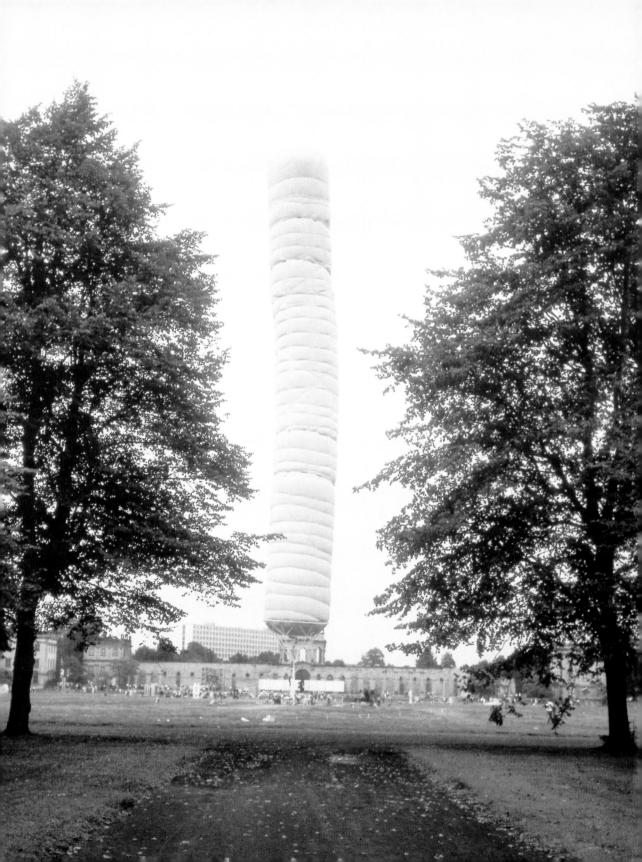

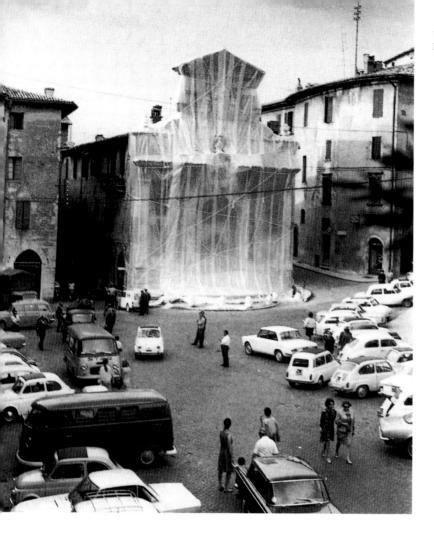

In 1977, Werner Spies took issue with the interpretations that were current amongst critics of the Christos in the earlier days.

"Christo's shrouded museums and monuments," wrote Spies, "and his draped, blind *Store Fronts*, so it was rashly stated, spoofed our faith in wrappings, in superficialities. However, unlike the world of advertising from which Pop art took its cues, Christo shifted the focus from packaging to contents. Warhol's Soup Cans, which ironically analyze the visual facets of a unit that is barely distinguishable from others like it, lie at the other extreme: they attest to a world consisting solely of externals. By contrast, in Christo's early works the outer skin and its glossy promises are transformed into a torn veil, behind which the viewer senses content of extreme variety: museums, land-scapes, monuments, life, death."

Albert Elsen, addressing the difficulties of the art-for-art's-sake position, concedes that there is "no rational purpose" for their projects, that they "do not satisfy our practical needs," and adds: "The projects are their own reason for being" – which might serve as the definition of art for art's sake. But Elsen goes on (and this is significant): "In the late twentieth century they are also tributes to artistic freedom. The Christos confront what does exist with

PAGE 35 TOP:

Wrapped Kunsthalle Bern, Switzerland, 1968 Polypropylene fabric and rope

PAGE 35 BOTTOM LEFT:

Wrapped Kunsthalle Bern, Switzerland, 1968 Polypropylene, fabric and rope

PAGE 35 BOTTOM RIGHT:

Wrapped Kunsthalle Bern, Switzerland, Project for the Fiftieth Anniversary of the Kunsthalle

Collage, 1968

Pencil, fabric, twine, photograph by Harry Shunk, charcoal and wax crayon, 71 x 56 cm Collection The Lilja Art Fund Foundation

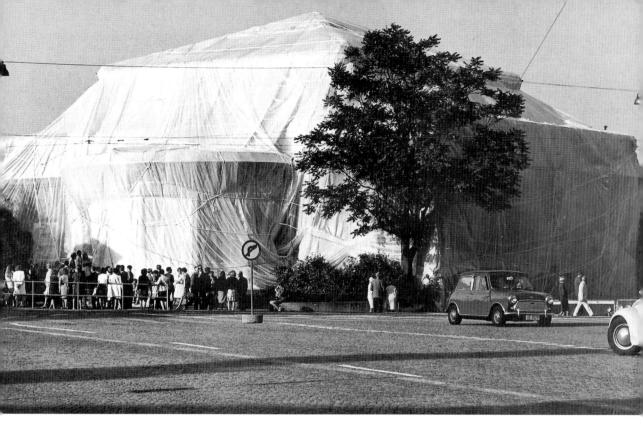

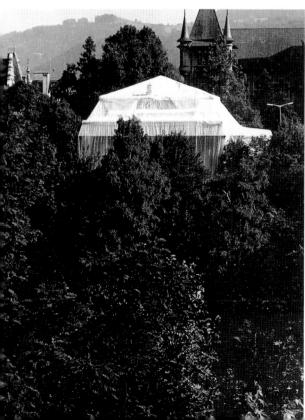

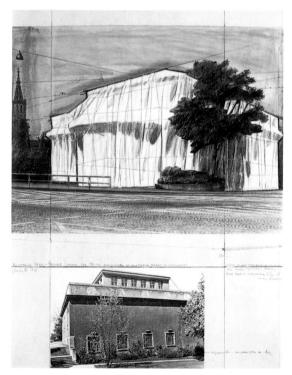

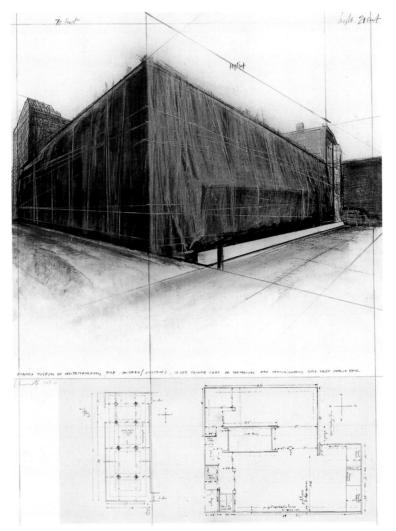

Wrapped Museum of Contemporary Art,
Project for Chicago
Drawing-collage, 1969–1981
Pencil, charcoal, wax crayon and tracing paper
107 x 83 cm

what they alone have determined can exist as a dramatic and beautiful form. Their art therefore is the result of intelligence and esthetic intuition added to the natural and built environment."

And Elsen concludes, in words that the present writer and many thousands of others can confirm: "We often understand all this only when we have experienced the projects directly and realized that, in a poetic way, our lives have been changed, as has our comprehension of what art can be and do." We all know Rilke's sonnet in which the poet stands before a statue of Apollo and feels the imperative of true art: "You must change your life." In some sense, the Christos' art is telling us the same.

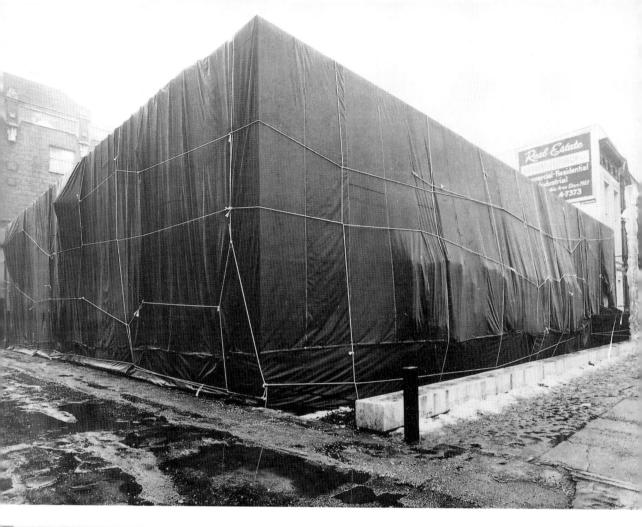

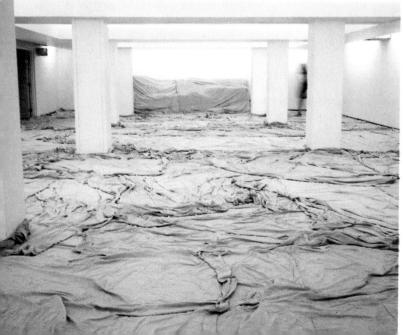

Museum of Contemporary Art, Chicago, Wrapped, 1969 Tarpaulin fabric and rope

Wrapped Floor and Stairway, Museum of Contemporary Art, Chicago, 1969 Cotton drop cloth and rope

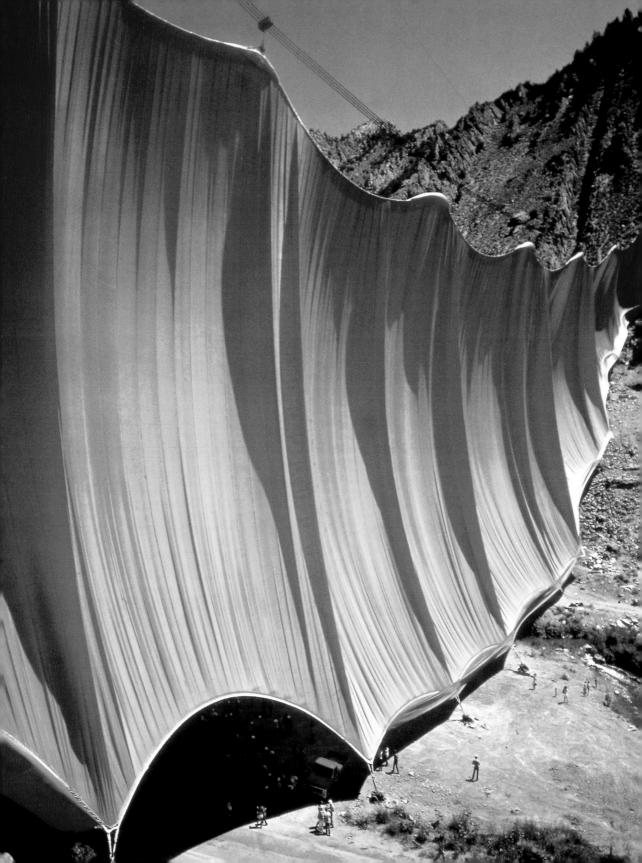

"The quintessential artists of their time"

Wrapped Coast, Valley Curtain, Running Fence

"Christos are art: artificial, constructed, man-made. Christos enhance the real world, sharpen our vision, make us more aware and observant, and finally, change the way we see things."

British art critic Marina Vaizey's statement may seem extravagant at first glance, but it repays careful consideration. "It is the age of information, and of propaganda, of advertising, packaging, presentation and wrapping," Vaizey reminds us. "We are inundated with images as never before." And in this brave new world, ancient longings familiarly surface among the people in it: "It is an age of mass production and of a longing for nature, the natural, the individual, the handmade. In the late twentieth century, people are acutely aware of an astonishing melange of contradictory hopes, dreams and desires, of many realities. And art is not only the physical embodiment of aspirations and faith, the way in which we can explain the world to ourselves, make patterns by which to grasp the unimaginable and incomprehensible, but also a commodity and a currency."

Against this background, they can be seen as the very personification of the contrarieties, aspirations, stresses and capabilities of art in the modern world. "Christo and Jeanne-Claude," declares Vaizey, "are the artists who inimitably have come to combine in their art the force of the individual creator with the methods of industrial and post-industrial society: capitalism, democracy, enquiry, experiment, collaboration and co-operation. In the course of so doing, Christo has moved from eastern Europe, from Bulgaria, to a Europe that was temporarily neutral, to Austria, to Paris, the traditional capital of the avant-garde, and finally, to New York, the post-war art capital, the essential consumerist, capitalist city."

Both in its shape and in its implications, the Christos' career has offered the definitive map of art in today's society.

In the decade from the late 1960s to late 1970s, the Christos created some of their most startlingly beautiful works in natural environments. The first, one of their greatest triumphs, came about when John Kaldor, a Sydney textiles businessman, invited the Christos to Australia to exhibit and lecture. The invitation coincided with their need for a site where they could realize a project to wrap a stretch of coastline, and the result was the *Wrapped Coast* (1968–1969, p. 41) – 100,000 square meters of wrapped coast at Little Bay, Sydney. To this day, the Christos' name has remained synonymous with that project in Australia: it was "a watershed for contemporary art in Australia," as Kaldor later observed, and "did more for contemporary art in Australia than any other single event," as Edmund Capon, Director of the Art Gallery of New South Wales, Sydney, put it.

Little Bay is about 14 kilometers south-east of Sydney. The craggy shoreline stretch that was wrapped was about 2.4 kilometers long, up to 250 meters

Wrapped Coast, Project for Little Bay, Australia Drawing collage, 1969 Pencil, wax crayon, aerial photograph, tape and woven polypropylene fabric sample, 71 x 56 cm

PAGE 38: Valley Curtain, Rifle, Colorado, 1970–1972 Nylon polyamide, steel cables, rope and concrete, 111 x 381 m

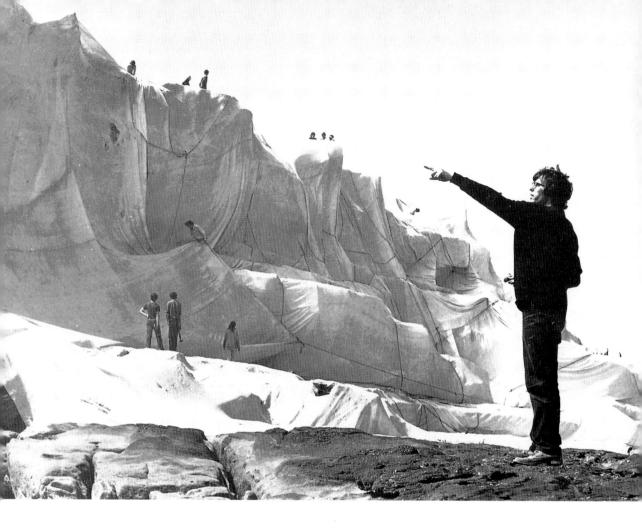

Christo at the Wrapped Coast, Little Bay, Australia, 1969

wide, and ranged from sea level at the sandy beach to a height of 26 meters at the northern cliffs.

90,000 square meters of erosion-control fabric (synthetic woven fiber, usually manufactured for agricultural purposes) were used for the wrapping and 56 kilometers of polypropylene rope, 1.5 centimeters in diameter, tied the fabric to the rocks.

A team of 15 professional mountain climbers, 110 laborers, and students of art and architecture from the University of Sydney and the East Sydney Technical College, toiled for some 17,000 man-hours, joined by a number of Australian artists and teachers eager to lend a helping hand. The expenses were met by the Christos from the sale of original preparatory drawings and collages.

It is worth emphasizing that after the ten-week period for which the coastal stretch was wrapped (from October to December 1969) the materials were removed and recycled and the site, which many thousands had visited, returned to its original state.

Landscape or environmental art of the Christos' kind has no exact parallels, but it is striking that comparable art – art that makes use of available natural landscape – does not always respect the environment as scrupulously. The fa-

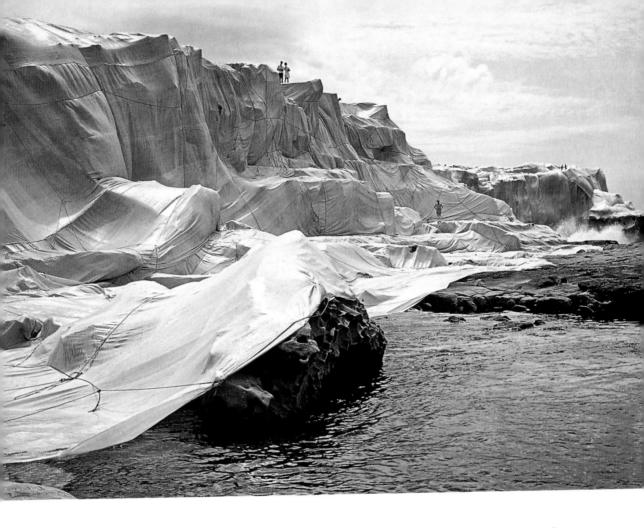

mous Blue Mountains north of Mount Sinai, for instance, are a breathtaking example of land art created in two months in 1980 by Belgian artist Jean Vérame, using only paint and brushes. As beautiful as this painted rocky landscape in a remote region is, though, it bears the artist's imprint permanently: the landscape cannot be returned to its natural condition – as it can after Christo and Jeanne-Claude have completed a project.

"Christo's art," wrote Albert Elsen in a 1990 Sydney exhibition catalog, "is the creation of temporary, beautiful objects on a vast scale for specific outdoor sites. It is in the populist nature of their thinking that they believe people should have intense and memorable experiences of art outside museums."

Or, as Jeanne-Claude put it to the present writer, "Each one of our works is a scream of freedom."

As the 1970s began, Christo and Jeanne-Claude conceived a number of projects on a smaller scale before going on to the *Valley Curtain*, and one of these is particularly worth mentioning. In 1970 the city of Milan organized a major exhibition to mark the tenth anniversary of the founding of the *Nouveaux Réalistes*. For this exhibition, the Christos devised two temporary projects.

Wrapped Coast, Little Bay, Australia, 1968–1969 (detail) Polypropylene fabric and rope, 250 x 2,400 m

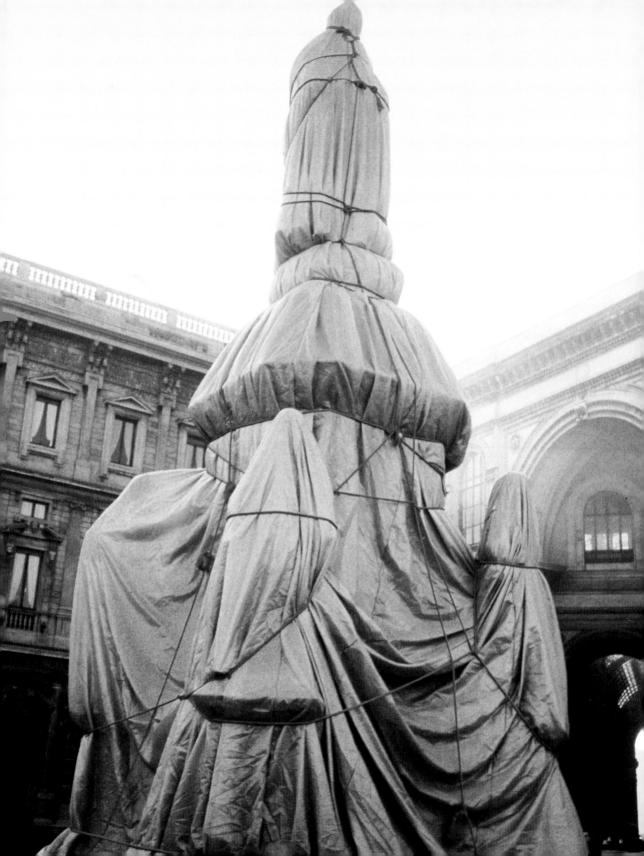

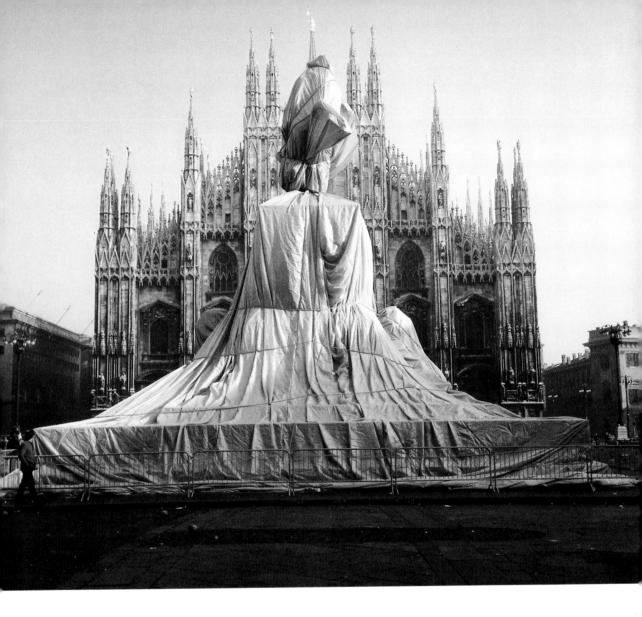

One was the wrapping of the monument to Leonardo da Vinci (p. 42), which remained enveloped in white fabric and rope on the Piazza della Scala for several days; the other was the wrapping of the monument to Vittorio Emanuele, King of Italy (p. 43). This imposing statue, in front of the Duomo in Milan, remained wrapped for forty-eight hours. The Milanese wrappings brought the issue of dignity (and its arguable infringement) to a head for the first time as the cases for and against were thrashed out.

The next significant outdoor project after the Australian coast near Sydney was the *Valley Curtain* at Rifle, Colorado (1970–1972, p. 38, 45), planning for which had begun in 1970. At 11 a.m. on August 10, 1972 at Rifle (between Grand Junction and Glenwood Springs in the Grand Hogback Mountain Range), a group of 35 construction workers and 64 temporary helpers, art school and college students, and itinerant workers, tied down the last of 27 ropes that secured

Wrapped Monument to Vittorio Emanuele, Piazza del Duomo, Milan, 1970 Polypropylene fabric and rope

DACE 42

Wrapped Monument to Leonardo, Piazza della Scala, Milan, 1970
Polypropylene fabric and rope

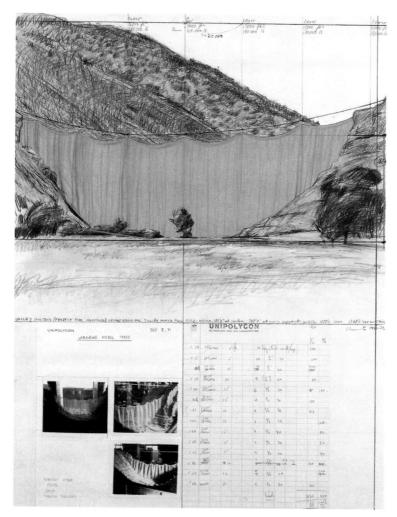

Valley Curtain, Project for Rifle, Colorado Collage, 1971–1972 Pencil, fabric, pastel, three photographs by Dimiter Zagoroff, charcoal, wax crayon, ballpoint pen and technical data, 71 x 56 cm

the 13,000 square meters of woven nylon fabric orange curtain to its moorings at Rifle Gap, 11 kilometers north of Rifle, on Highway 325.

The curtain measured 381 meters in width and up to 111 meters in height, and remained clear of the slopes and the valley floor. The cables holding it in place spanned 417 meters, weighed fifty tons, and were anchored to 800 tons of concrete foundations.

So much hard work! And so much time (28 months in all) in the making! And the following day, August 11, a gale swept through the valley at a speed of 100 kilometers per hour, and made it necessary to begin removal: the temporary nature of the Christos' works was being driven home by the elements. "He momentarily intervenes," as Albert Elsen has aptly put it, "creating 'gentle disturbances' between earth and sky in order to refocus our impressions [...] The Christos believe the temporary nature of their projects gives them more energy and intensifies our response. But once they have wrapped a structure or intervened in a place, they are forever associated with that site." Again and again, temporariness becomes the issue – and arguably a more pertinent issue than the somewhat airy "forever" invoked by Elsen, which would

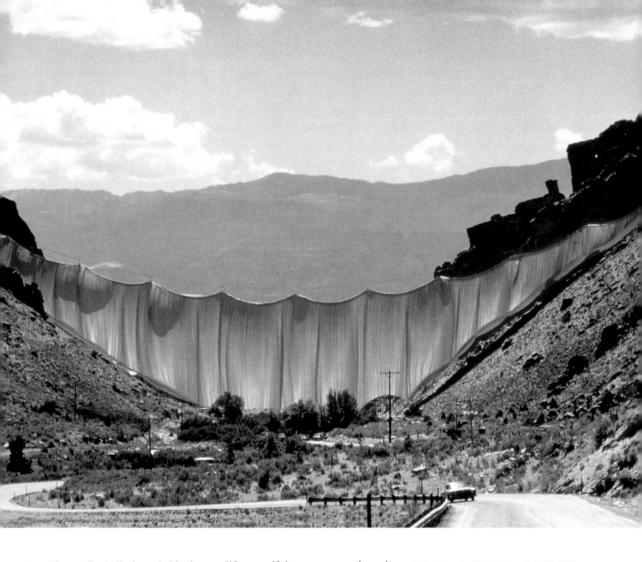

be a "forever" wholly bounded by human lifespans if there were no other witness to the Christos' projects than the memories of those who were there. "After the work has been prepared, and after the work has been put up and then taken down, it remains" asserts Marina Vaizey. "It remains in the memory of the thousands who will have experienced it first hand; it remains in the memory of those who will have seen the work on film, on television, in the newspapers. And an integral part is Christo's own portable art, the magnificent sketches, drawings, collages and prints that are both his working drawings and works of art in their own right." Memory is limited in time, but the accompanying and preparatory works Christo makes in the course of the projects palpably have the age-old function of defying time and insisting that they (and thus the artwork as a whole) will endure. The temporary quality of the projects is an aesthetic decision for the sake of endowing the works of art with a sense of urgency to be seen and a feeling of tenderness that arises from their very transitoriness. It is these emotions of love and tenderness that Christo and Jeanne-Claude want to offer to their works as an added value: a new aesthetic quality.

Valley Curtain, Rifle, Colorado, 1970–1972 Nylon polyamide, steel cable, rope and concrete, 111 x 381 m

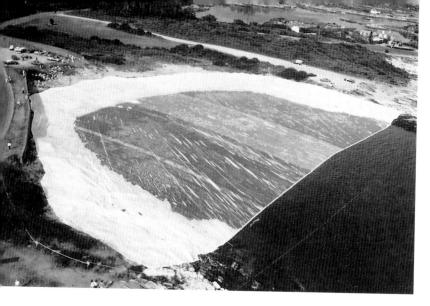

Ocean Front, Newport, Rhode Island, 1974 Woven polypropylene fabric, floating on the water, 128 x 98 m

Before their next major landscape project, the Christos returned to the urban setting once more (town and country have alternated throughout their career) for the *The Wall – Wrapped Roman Wall* work (1974, p. 47). The wall in question was at the end of the Via Veneto, one of Rome's busiest thoroughfares, near the gardens of the Villa Borghese. Two thousand years old, it was built under the Emperor Marcus Aurelius. Christo and Jeanne-Claude wrapped a length of over 259 meters in polypropylene fabric and rope; and, for the duration of forty days, three of the four wrapped arches continued to be used by traffic and the fourth by pedestrians. The response in Rome was a lively one.

That same year, the Christos created the *Ocean Front* (1974, p. 46) at Newport, Rhode Island. For eighteen days, 14,000 square meters of white woven polypropylene fabric covered the surface of the water of a cove shaped like a half-moon at King's Beach, on the southern exposure of Ocean Drive, facing that portion of the Long Island Sound that meets the Atlantic at Rhode Island. As with the *Valley Curtain* project, Mitko Zagoroff, John Thomson and Jim Fuller were the engineers who designed and supervised the construction itself. "Work began," read the Christos' official bulletin, "at 6:00 a. m. on Monday, August 19, 1974. The bundled fabric was passed from the truck to pairs of nonskilled workers wearing life jackets. They carried the 2,722 kilograms of fabric to the water on two-by-fours stretched between them. The fabric was laced to a wooden boom 120 meters long, secured with twelve Danforth anchors, holding in place the frontal edge of the floating fabric."

Christo and Jeanne-Claude want their ideas and proposals out in the public arena, where they can be inspected, debated and considered from every angle, in a fashion that is more profoundly democratic in implication than the approaches taken by many another self-proclaimed egalitarian in art.

Arguably the loveliest and most spectacular of the Christos' epic projects was the *Running Fence* (1972–1976, p. 49), 39.5 kilometers long, in Sonoma and Marin Counties north of San Francisco. Against considerable opposition, the Christos won and put up their long white fence stretching in from the Pacific Ocean, across farms and past villages. To reach this point, they had gone through 18 public hearings and three sessions at the superior courts of California, and had drawn up an environmental impact report the

The Wall, Project for a Wrapped Roman Wall, Rome

Drawing, 1974 Pencil, charcoal and wax crayon, 165 x 106.6 cm

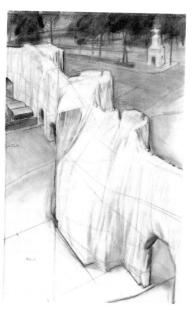

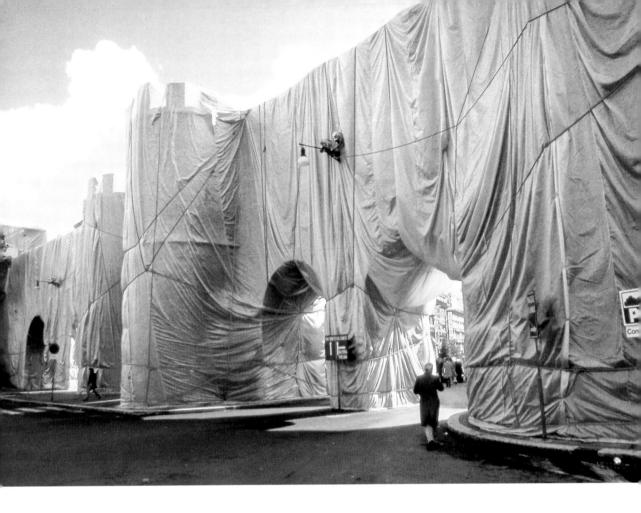

size of a telephone directory. It was the first E.I.R. ever done on a work of art. But the reward was visible to all. The beauty of the snaking fence was enhanced by its oblique similarity to the Great Wall of China; and that similarity was eerily underpinned by the coincidental fact that Chairman Mao Tse-Tung died on the day before the *Running Fence* was completed. Coincidences are not germane to a work of art, but they can unwittingly heighten its impact.

The *Running Fence*, 5.5 meters high and 39.5 kilometers long, extending across the properties of fifty-nine ranchers near Freeway 101 north of San Francisco, and following the rolling hills and dropping down to the Pacific at Bodega Bay, was completed on September 10, 1976. All the white nylon fabric (160,000 square meters), the steel cables (145 kilometers) and poles (2,060), and the earth anchors (14,000), were designed for complete removal: no visible evidence remained on the hills of Sonoma and Marin Counties to indicate that the *Running Fence* had ever been there. The removal began (as agreed with the ranchers and the authorities) fourteen days after completion.

"They borrow land, public structures and spaces," Albert Elsen wrote.
"Unlike a warrior-ruler such as Napoleon, who is forever associated with sites by force of arms, the Christos' permanent identification with places and historic structures is by the force of art." On the matter of permanence, opinion

The Wall-Wrapped Roman Wall, Rome, 1974 Polypropylene fabric and rope, 15 x 259 m

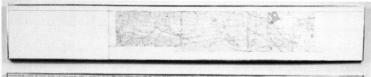

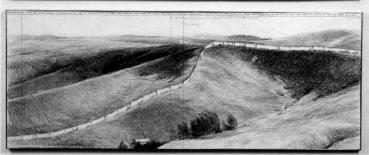

Running Fence, Project for Sonoma and Marin Counties, California
Drawing, 1973, in two parts
Pencil, wax crayon and topographic map, in two parts: 35.5 x 244 and 91.5 x 244 cm

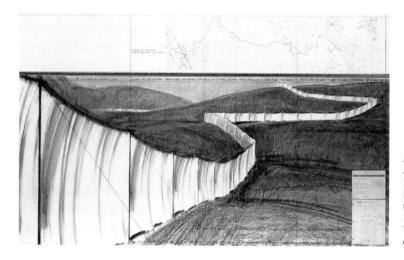

Running Fence, Project for Sonoma and Marin Counties, California
Drawing, 1976, in two parts:
Pastel, pencil and charcoal, wax crayon, technical data and map, 38 x 244 and 106.6 x 244 cm
Washington D.C. National Gallery of Art, gift of Dorothy and Herbert Vogel

is naturally still divided – not least because it is obviously too early to say; in any case, the Christos themselves would be the first to object to the introduction of the idea of permanence into art projects defined by their temporary nature. But the artists' identification with their sites can be confirmed by anyone who drove the 65 kilometers of public roads in Sonoma and Marin Counties from which the *Running Fence* was meant to be viewed. The excited international response to the work reflected a simple truth: that the Christos, in impressing their own intuition of beauty upon the landscape, were expressing intuitions shared by many.

The Wrapped Walk Ways (1977–1978, p. 53) that followed (in Kansas City's Jacob L. Loose Park) were like chamber music after a grand symphony in the Romantic tradition, but they possessed their own intimate beauty. To prepare the 12,540 square meters of saffron nylon fabric, an army of seamstresses at a West Virginia factory and on site in the park were employed, and a task force of 84 people was needed to install the material. Over four kilometers of walkways in formal gardens and jogging paths, remained covered from October 4 to 18, 1978, after which the material was removed and given to the Kansas City Parks Department for recycling, and the park itself restored to its original condition.

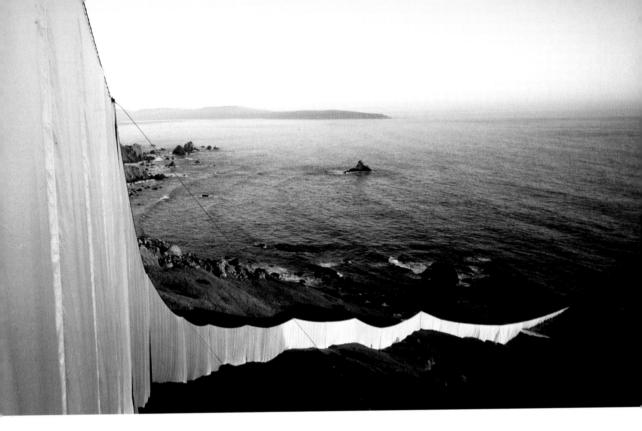

The project was popular with the public: as so often, part of the Christos' charismatic success derived from their ability to mobilize large numbers of people, inculcating a team spirit and a joint sense of achievement. In this respect, their orchestrated projects were compared by some critics with theatrical or musical enterprises.

Marina Vaizey reminds us that the co-operative approach has time-honoured roots in artistic tradition: "We are used to the notion of collaborative projects in art and technology in two different ways. In both art and design there is the notion of the studio, of apprentices, students, assistants, and specialists working under artistic direction. This is a practice well-established in the early Renaissance, and which evolved from the ways in which craftsmen and artists were once indistinguishable philosophically, although each individual might have a speciality. For example, in northern Italy in the fourteenth century, the creation of devotional works of art required several skills, not necessarily all practised by the same person. Some prepared the panels, some were specialist gilders, some painters, and the person to whom the panel was ascribed was in charge of the overall design and composition, although he would not have made it entirely on his own."

"They have harnessed the methods of democratic capitalism to the making of art," Marina Vaizey has observed. "Their methods are inseparable from their art [...] They and their work are at home in the centre of cities, and in remote countryside. They have made huge projects that have existed for only days or weeks, then to vanish forever, memorialized only by the media, and in the memories of those hundreds of people involved in the

Running Fence, Sonoma and Marin Counties, California, 1972–1976 Nylon fabric, poles and steel cables, 5.5 m x 39.5 km

In order to obtain the necessary permits from the governmental agencies in California, the artists had to prepare a 355-page environmental impact report, 1972–1976

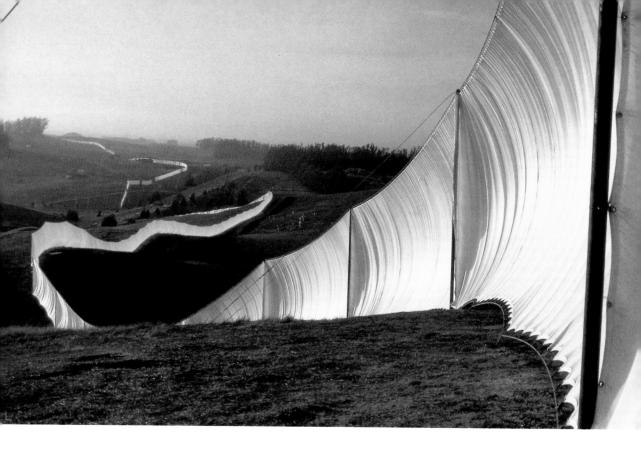

Running Fence, Sonoma and Marin Counties, California, 1972–1976 Nylon fabric, poles and steel cables, 5.5 m x 39.5 km

process of their making." The immortality of artworks, inscribed over the centuries into our consciousness of sculpted stone or printed page or long-surviving melody, has never been more radically defied than by the Christos' works – often involving elaborate technical operations, months or years of planning, and the labor of many, only to disappear, leaving no trace at the site where they were created.

PAGE 51

Running Fence, Sonoma and Marin Counties, California, 1972–1976 Nylon fabric, poles and steel cables, 5.5 m x 39.5 km

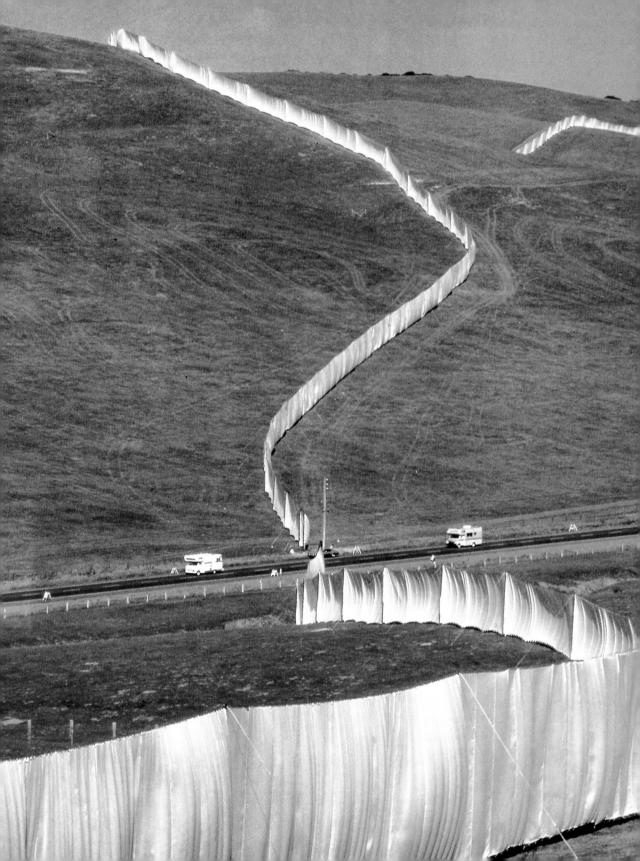

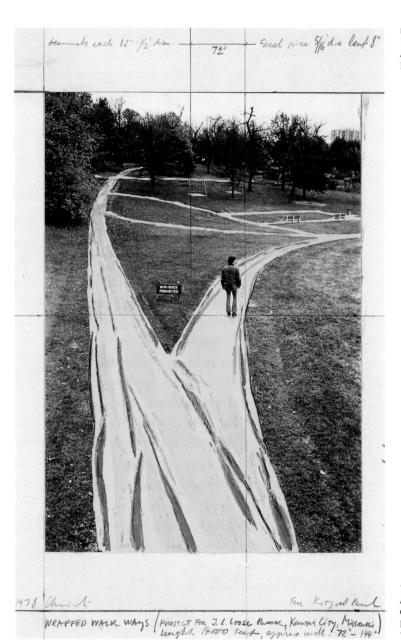

PAGE 53: Wrapped Walk Ways, Jacob L. Loose Park, Kansas City, Missouri, 1977–1978
Fabric covering 4.5 km of walkways

Wrapped Walk Ways, Project for Jacob L. Loose Park, Kansas City, Missouri Collage. 1978 Pencil, enamel paint, photograph by Wolfgang Volz, wax crayon and charcoal, 38 x 28 cm

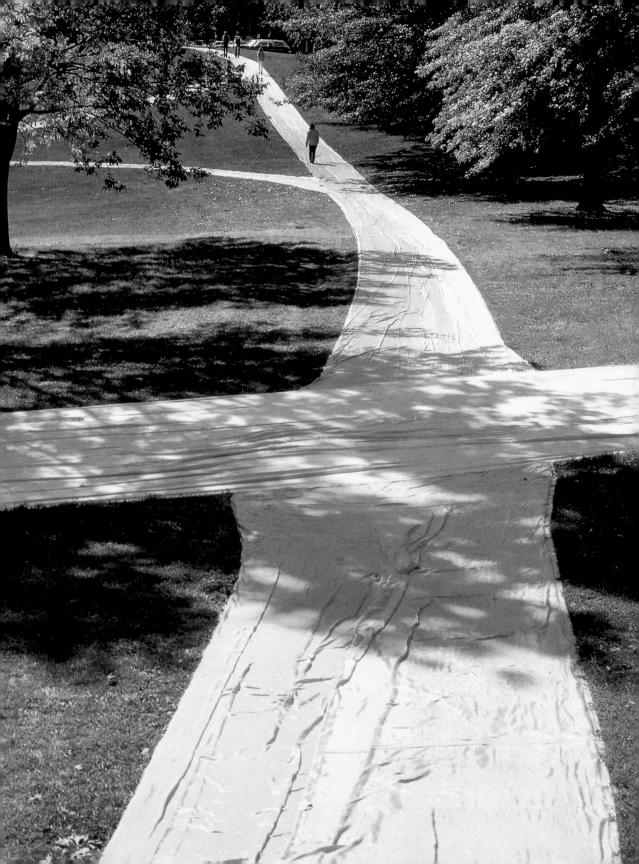

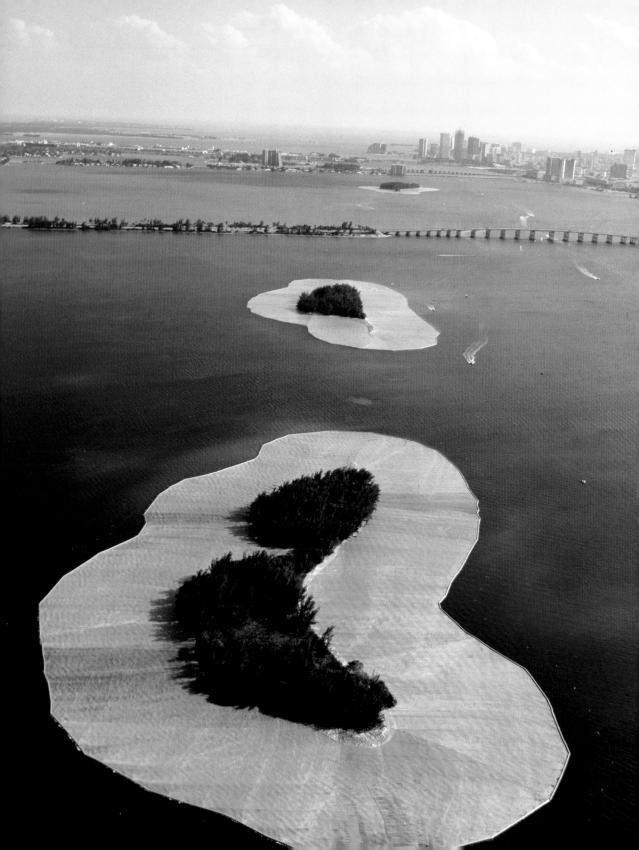

"The only natural choice"

Surrounded Islands, Pont-Neuf, The Umbrellas

One of the most spectacular projects conceived and created by the Christos, a personal favorite of the present writer, was the *Surrounded Islands* (1980–1983, p. 54) in Biscayne Bay, Greater Miami, Florida. This mammoth project – accommodated to the natural environment, symbiotically blending with it without harm or disturbance – was a work of great beauty, delicacy and poetry, as well as daring, and posed considerable risk and technical difficulty.

In a project they saw as an urban enterprise, the Christos set out to surround eleven man-made islands set squarely amidst the millions that populate Greater Miami, islands that were mostly used for dumping garbage. The preparations were long and complex, and involved, as in other projects, drawings, collages and photographs, as well as documentation and numerous meetings with government and local officials, in order to secure permission. From April 1981, a team of attorneys, a marine engineer, four consulting engineers and a building contractor, a marine biologist, an ornithologist, and an expert on mammals, all worked steadily on preparing the Surrounded Islands project. Marine and land crews picked up debris from the eleven islands, putting refuse in bags and removing some 40 tons of rubbish in all. Permits were obtained from the Governor of Florida, the City of Miami Commission, and numerous other authorities, including the US Army Corps of Engineers: "The US Army Corps of Engineers permit alone is six inches thick," reported the Miami Herald, "thicker than a Bible, thicker than the Websters Third International Dictionary unabridged edition." And the result was one of the most unforgettable and poetic sights art has produced in modern times.

I well remember taking a helicopter and flying over the islands. The panorama that was revealed before us showed yet again how precious was the Christos' gift for transformation. The landscape *per se* had been metamorphosed, for a short time, into another, beautiful reality, with luminous pink surrounds of fabric shining in breathtakingly unusual harmony with the tropical vegetation of the islands, the light of the Miami sky, and the colors of the shallow waters of the bay. Claude Monet's *Water Lilies* (1916, p. 58) inevitably came to mind; the islands seemed to be floating pads of verdure and blossom, observed (rather than made) by an eye sensitive to every nuance of light and color.

The choice of pink fabric was far from accidental. "Pink, with the sweetish overtones of frangipani, will strike the stranger to Miami within a matter of hours as the symbolic color of the area," observed Werner Spies. "Pink was the only natural choice of color in that part of the country – the color of a euphoric artificiality." In the Christos' use of the color, there was both humor and affection. And the color did not go unglossed by the press. "In Miami," noted *The Orlando Sentinel* (April 17, 1983), "pink used to mean flamingos, sunsets and art deco hotels. Now it means Christo."

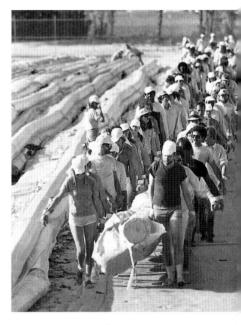

Surrounded Islands, Biscayne Bay, Greater Miami, Florida, during installation. May 1983

PAGE 54: Surrounded Islands, Biscayne Bay, Greater Miami, Florida, 1983 603,850 square meters of fabric floating around 11 islands

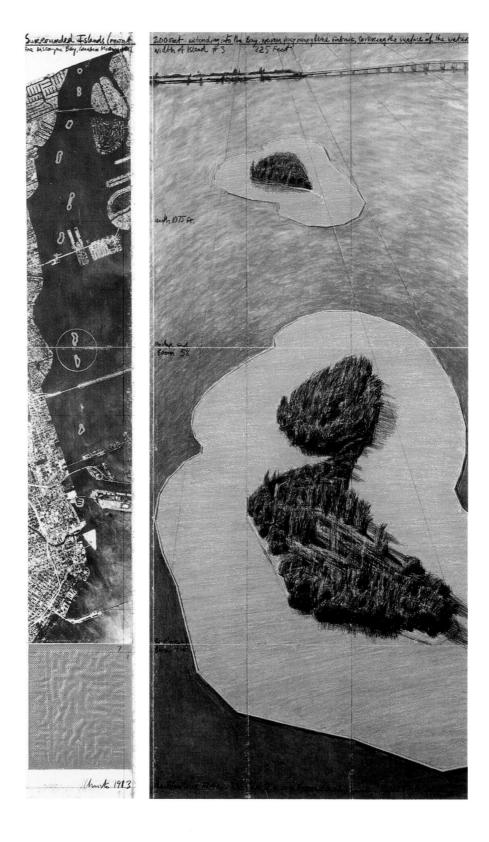

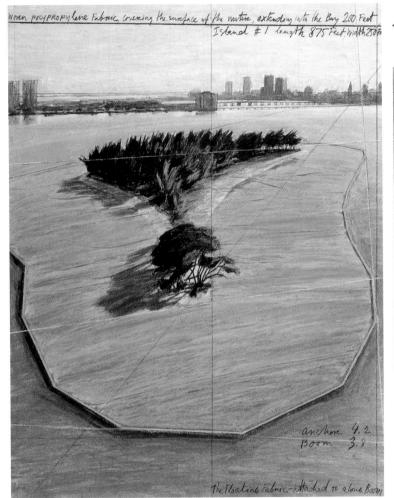

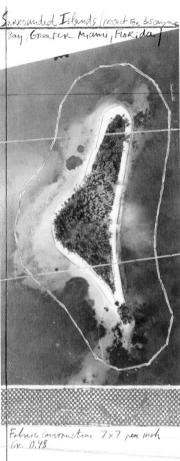

The Christos' "soft intrusion into the life of the metropolis" (as Werner Spies aptly put it) was completed on May 7, 1983, and the eleven islands in the area of Bakers Haulover Cut, Broad Causeway, 79th Street Causeway, Julia Tuttle Causeway and Venetian Causeway were surrounded with 60 hectares of pink woven polypropylene fabric covering the surface of the water, floating and extending 60 meters out from each island into Biscayne Bay. The fabric had been sewn into 79 patterns to follow the contours of the islands, and the sewing, done at the rented Hialeah factory, took from November 1982 until April 1983. A flotation strip was sewn into each seam, and, at the Opa Locka Blimp hangar, the sewn sections were accordion-folded to ease the subsequent unfurling on the water. This unfurling was begun on May 4, and, once the work was accomplished, the *Surrounded Islands* were tended day and night by over a hundred monitors in inflatable dinghies.

The impact of this remarkable project went far beyond the local scene – though no doubt the many who beheld the sight for themselves during the two weeks of installation were left with an impression permanently engraved upon their minds. At the location the Christos' project created a two week boom

Surrounded Islands, Project for Biscayne Bay, Greater Miami, Florida

Musto 1983

Collage, 1983, in two parts Pencil, fabric, pastel, charcoal, wax crayon, enamel paint, aerial photograph and fabric sample, 71 x 56 and 71 x 28 cm

PAGE 56:

Surrounded Islands, Project for Biscayne Bay, Greater Miami, Florida

Drawing, 1983, in two parts Pencil, charcoal, pastel, wax crayon, enamel paint, aerial photograph and fabric sample, 244 x 38 and 244 x 106.6 cm Germany, Private collection

Surrounded Islands, Project for Biscayne Bay, Greater Miami, Florida Drawing, 1983

Pencil, charcoal, pastel, wax crayon, enamel paint, aerial photograph and fabric sample, in two parts: 165 x 106.6 and 165 x 38 cm Washington D.C. National Gallery of Art, gift of Dorothy and Herbert Vogel

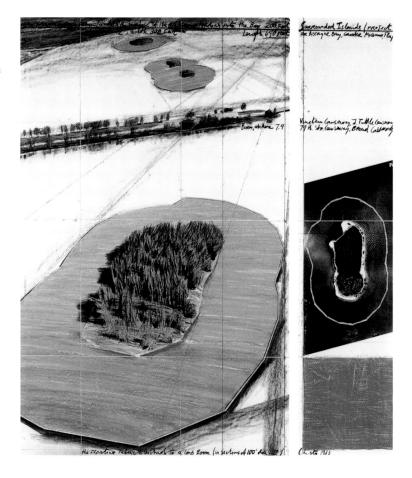

Claude Monet
Water Lilies, 1916
Oil on canvas, 200 x 200 cm
Tokyo, The National Museum of Western Art
(The Matsukata Collection)

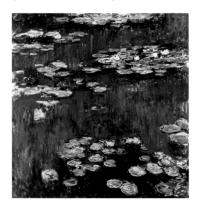

for the Miami tourist economy. One helicopter company sold 5,000 seats at \$ 35 a time to witness the sight from above. But "around the globe," as *The New York Times* reported (May 15, 1983), the *Surrounded Islands* were given "prime time exposure by networks and newspapers [...] right up there with such headline stories as Hitler's diaries, the Israel-Lebanon draft agreement and the nuclear arms freeze."

Very few people realize that the *Surrounded Islands* project was the brain child of Jeanne-Claude, who for the last four decades has been Christo's energetic partner in all their projects, both large and small, realized and unrealized.

That exposure, and the controversies that have invariably accompanied it, have become an inseparable part of the Christos' art projects. To the avantgarde of yesteryear, thumbing the nose at entrenched bourgeois philistinism – or, at least, imagining that opposition equalled philistinism – was always a means to obtain credibility, artistic vindication and success. The approach taken by the Christos is a different one. As artists whose integrity, talent and professional seriousness have been widely attested, they enlist the attention generated by the media, and turn it to their advantage, in good faith, relying on the mere fact of debate to consolidate their position and strengthen their case. At a time when many would still take the easy way out and, if they could, dismiss them as charlatans, the use of powerful allies makes the best of sense.

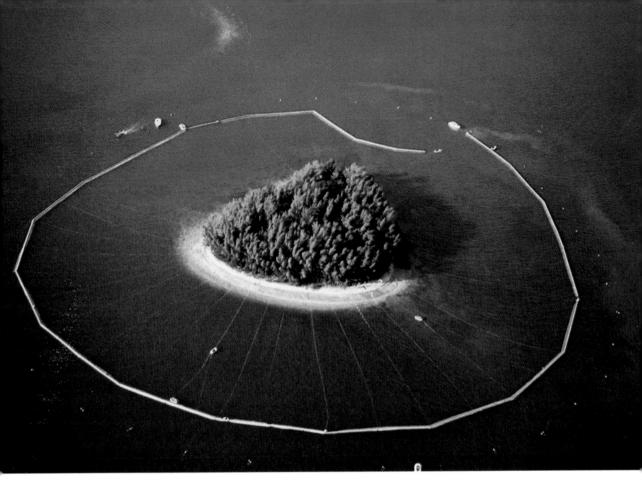

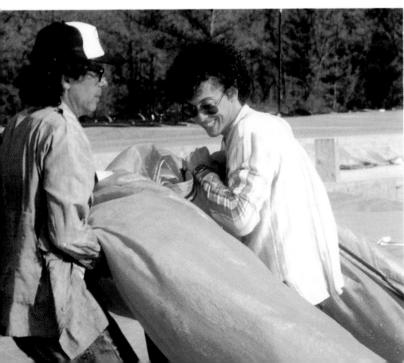

During the installation of *Surrounded Islands*, May 1983

Christo and his son Cyril during the installation of *Surrounded Islands*, May 1983

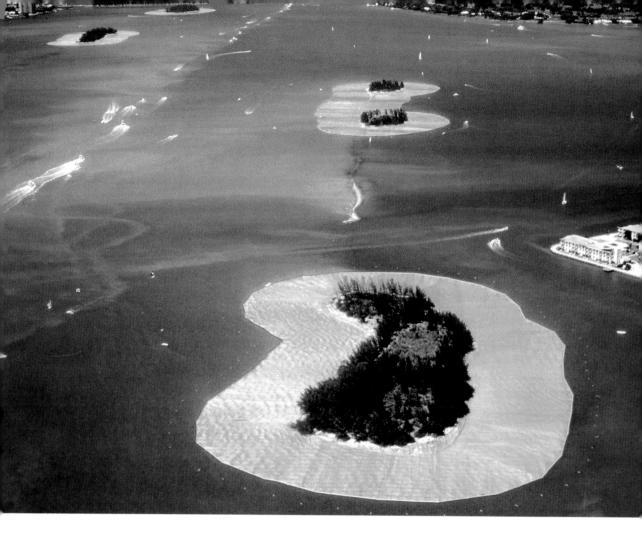

Surrounded Islands, Biscayne Bay, Greater Miami, Florida, 1980–1983 603,850 square meters of fabric

Exposure and controversy are, quite simply, a means of generating the interest, and thus the funds, that go into the increasingly costly and complex projects conceived by the Christos, man and wife. (And the money the Christos put into their projects frequently finds its way into the coffers of local communities, thus providing them with the multiple benefits of art, publicity, and plain cash.)

The Christos were still finding that objections usually accused them of frivolity, their projects of not being art, accusations that came mostly from other artists. And the same battles needed to be fought once again over the next project, the *Pont Neuf Wrapped*. Opposition to wrapping the bridge (the oldest in Paris) was strong.

Begun under King Henri III, the Pont-Neuf was completed in 1606, during the reign of Henri IV. From 1578 to 1890 the Pont-Neuf underwent continual changes, sometimes of an extravagant sort, such as the construction of shops on the bridge under Jacques Germain Soufflot, or the building, demolition and rebuilding of the substantial rococo structure that housed the Samaritaine's water pump – which was subsequently demolished once again. With so long a tradition, in so tradition conscious and great a metropolis as Paris, the Pont-

PAGE 61: Surrounded Islands, Biscayne Bay, Greater Miami, Florida, 1983 (aerial view) 603,850 square meters of fabric

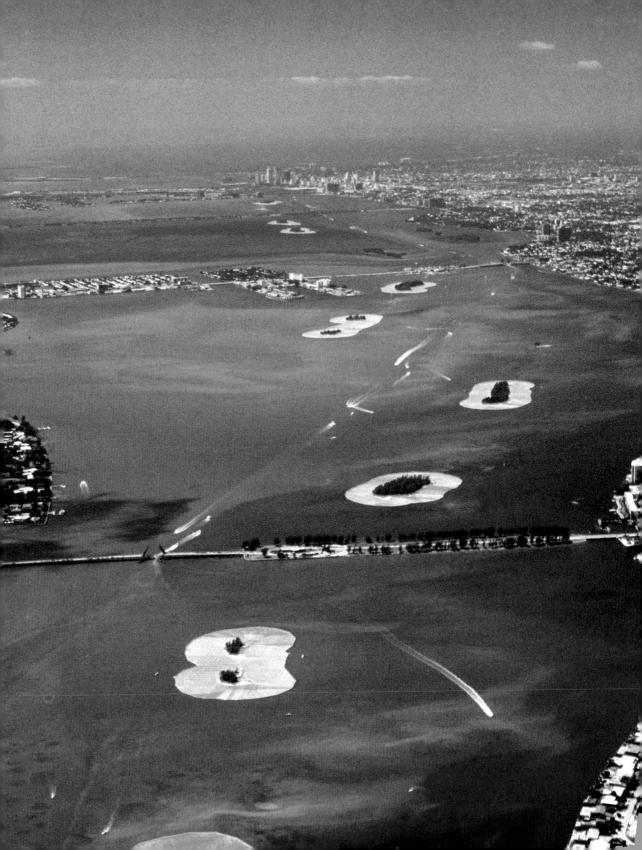

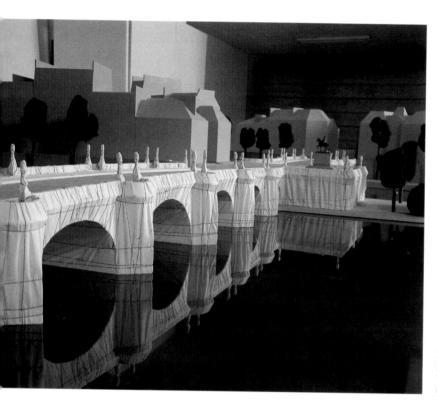

PAGE 63:

The Pont Neuf Wrapped, Project for Paris Collage, 1985, in two parts Pencil, fabric, twine, pastel, charcoal, wax crayon, aerial photograph and technical data,

30.5 x 77.5 cm and 66.7 x 77.5 cm

The Pont Neuf Wrapped, Project for Paris Scale model (detail), 1985 Wood, Plexiglas, fabric and twine, 82 x 611 x 478 cm

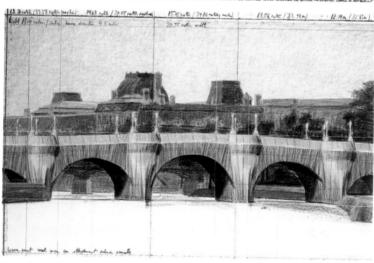

The Pont Neuf Wrapped, Project for Paris
Drawing, 1985, in two parts
Pencil, charcoal, pastel, wax crayon, map and
fabric sample, 38 x 165 and 106.6 x 165 cm

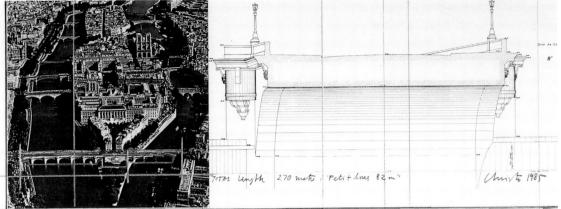

THE POWT NEW , WRAPPED (those of the paris) and dutume of de la tregissenie, Ele de la Cité, and Conti, a des Gels, Augustity

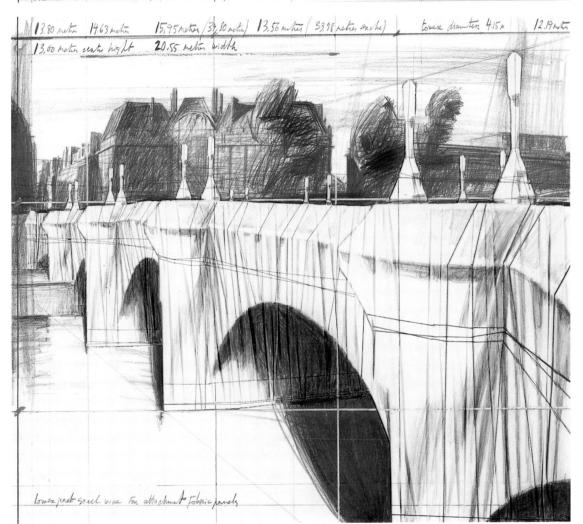

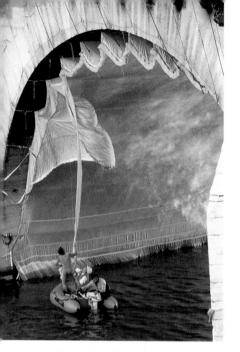

The Pont Neuf Wrapped, Paris, during installation, September 1985

Neuf was naturally at the center of a storm of controversy when the Christos proposed to wrap it. No other bridge in Paris is so thrilling, so laden with cultural and historical importance. Many artists in the past have painted the bridge, among them J. M. W. Turner, Auguste Renoir, Camille Pissarro, Paul Signac, Pablo Picasso and Albert Marquet. Furthermore, since ancient times, the building of a bridge has had an aura of the religious, and has partaken of ritual significance. Speculation was rife among the controversialists: wrapping the bridge would harm it, or those who crossed it or passed below, or would rob the stone of its original appearance, or would otherwise desecrate a cultural totem. For the Christos, winning approval was an uphill battle that took ten years. They began, as so often, democratically – with the people who lived in the immediate neighborhood, talking to them, persuading them. And their campaign continued all the way to the French President and the mayor of Paris, both of whom had to give their approval before the project could finally proceed.

At long last, permission was given by Jacques Chirac, the former mayor and now president of France, and by his arch rival, President François Mitterand. After blocking the Rue Visconti with oil barrels, the Christos had repeatedly tried to embark on Parisian projects, but to no avail. Wrapping the Pont Neuf – which proved a triumphant success in the event – was a gesture, the symbolic repayment of a debt that Christo felt he owed to France, his first true home after his escape from behind the Iron Curtain. The bridge arguably symbolized (among other things) his own crossing from the Communist to the Free World, and his new-found freedom to express himself in art.

On September 22, 1985, a group of 300 professional workers completed the temporary work of art *The Pont Neuf Wrapped* (1975–1985, p. 65). They had used nearly 41,000 square meters of woven polyamide fabric, silky in appearance and the color of golden sandstone, and with it they had covered the sides and vaults of the Pont Neuf's twelve arches (without obstructing river traffic); the parapets to ground level; the sidewalks and curbs (pedestrians walked on the fabric); all the street lamps on both sides of the bridge; the vertical part of the embankment on the western tip of the Ile de la Cité; and the esplanade of the Vert-Galant. The fabric was restrained by 13,076 meters of rope and secured with over twelve tons of steel chains encircling the base of each tower.

The Charpentiers de Paris, headed by Gérard Moulin, with a team of French sub-contractors, were assisted by the team of engineers (Vahé Aprahamian, August L. Huber, James Fuller, John Thomson and Dimiter Zagoroff) who have worked on a number of the Christos' projects, under the direction of Theodore Dougherty. Project director Johannes Schaub had submitted detailed plans and a work method description, which had been approved by the Parisian and state authorities.

And the result? All the detail of the bridge had become invisible – "as if" (wrote Werner Spies) "it had been designed by Adolf Loos, who declared that all ornamentation is a crime." The visual impression made by the wrapped bridge was one of post-modern, aerodynamic architecture that preserved one or two anachronistically medieval features. Those who asked after the point of the enterprise were well answered by one of the Chamonix mountaineers who had been engaged in binding up the vertical walls, and who observed that he really had no idea why he scaled the summits of mountains, either. The thing must be its own vindication: it is done because it is possible to do it. That bridges have always stood for the transitory and passing in life, and for the perilous crossing of the abyss, is a symbolic meaning that will appeal to some, perhaps in the same way as the statistics appeal to others; but the Christos' work, making its most complete and memorable impact on site, to

PAGE 65: **The Pont Neuf Wrapped, Paris**, 1975–1985 Polyamide fabric and rope

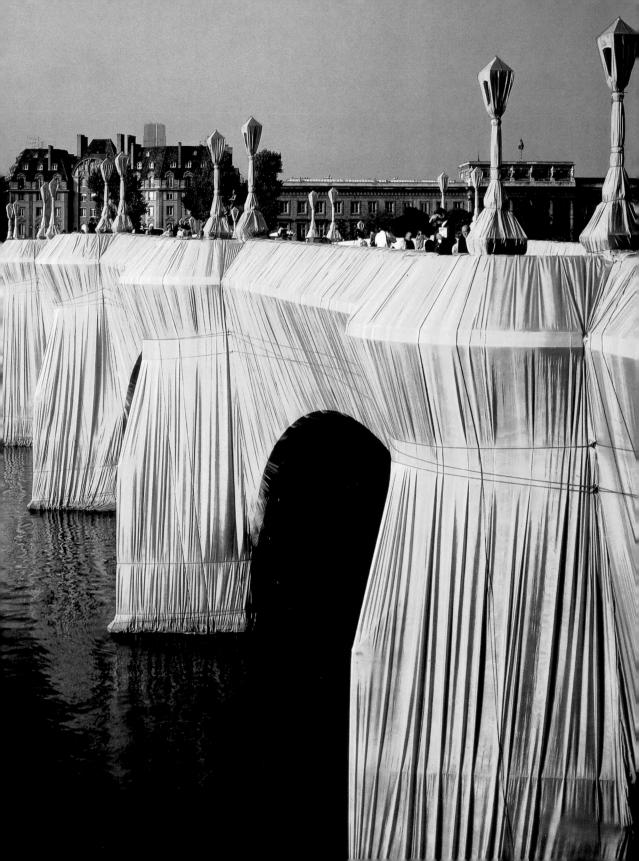

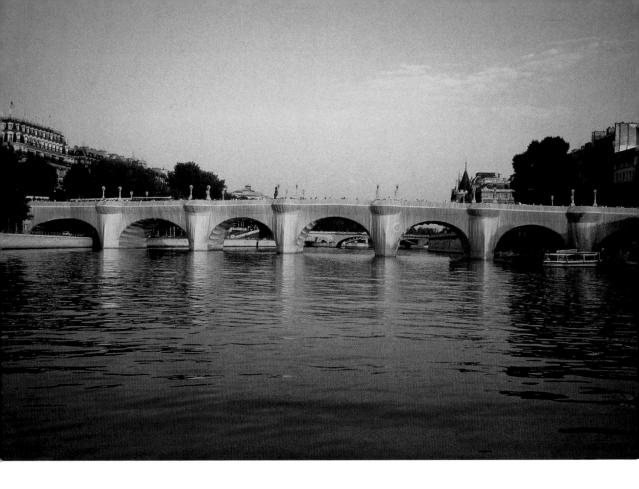

The Pont Neuf Wrapped, Paris, 1975–1985 Polyamide fabric and rope

those who travel to see it, tends to insist on its own simplicity, despite the complexity of the operations involved. After the completion of wrapping the bridge, even those who first opposed it were astonished and impressed by the great artistic beauty of the project.

Discussing his work with Masahiko Yanagi for an exhibition catalog of his work (Annely Juda Gallery, London, 1988), Christo said: "I see my projects as having two major periods or steps. One I like to think of as the 'software period' and the other as the 'hardware period'. The software period is when the project is in my drawings, propositions, scale models, legal applications, and technical data. That software period is the more invisible because there are only projections of how the bridge will look. This is different from an architect or a bridge builder, for example, who can refer to previous skyscrapers or previous bridges, and they can make their work look about the same. But because we had never wrapped a bridge, each proposition is unique, even for us [...] Really how the bridge would look at the end was not defined in 1975 when I had the idea [...] The realized work of art, The Pont Neuf Wrapped, is the accumulation of the anticipation and the expectation of a variety of forces: formal, visual, symbolic, political, social, and historical. This is why when we arrive at the hardware period – the second part – the physical making of the work is probably the most enjoyable and rewarding because it is the crowning of many years of expectation. The hardware period is very much like a mirror, showing what we have worked at. The final object is really the

PAGE 67: **The Pont Neuf Wrapped, Paris**, 1975–1985 Aerial view

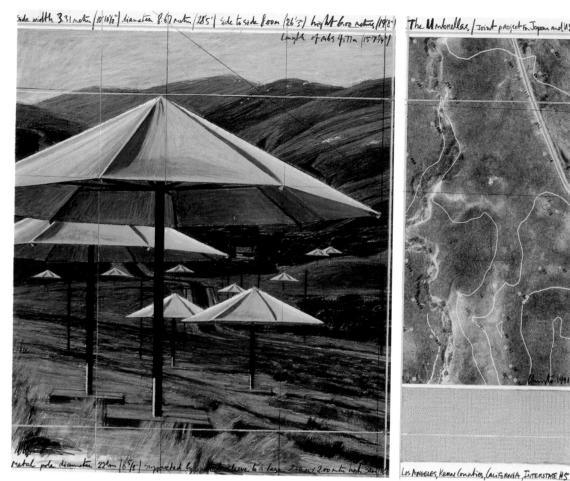

The Umbrellas, Joint Project for Japan and USA Collage, 1991, in two parts Pencil, fabric, pastel, charcoal, wax crayon, enamel paint, topographic map and fabric sample, 77.5 x 66.7 cm and 77.5 x 30.5 cm

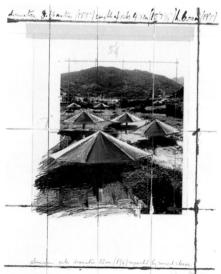

The Umbrellas, Joint Project for Japan and USA Collage, 1991 Pencil, enamel paint, photograph by Wolfgang Volz, charcoal, wax crayon and tape, 35.5 x 28 cm

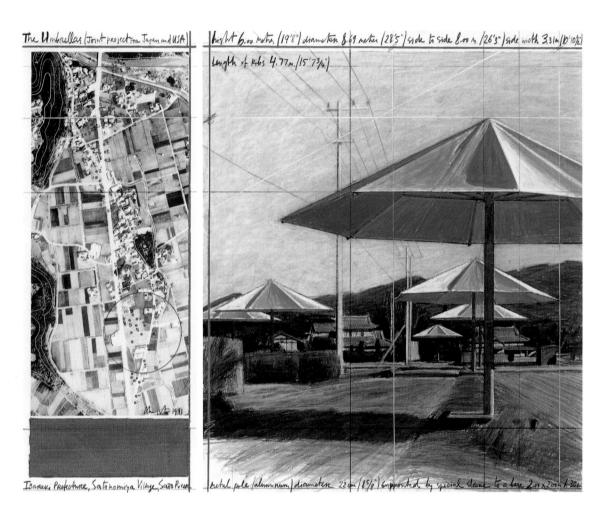

The Umbrellas, Joint Project for Japan and USA
Collage, 1991, in two parts
Pencil, fabric, pastel, charcoal, wax crayon, aerial photograph and fabric sample, 77.5 x 30.5 and 77.5 x 66.7 cm

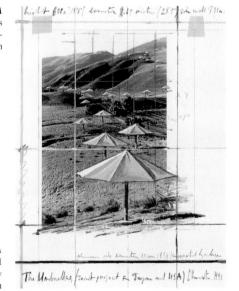

The Umbrellas, Joint Project for Japan and USA
Collage, 1991
Pencil, wax crayon, enamel paint, charcoal, photograph by
Wolfgang Volz, ballpoint pen and tape, 35.5 x 28 cm

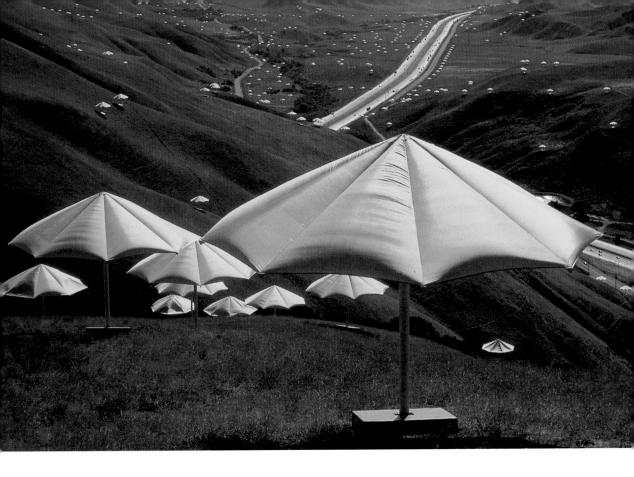

The Umbrellas, Japan – USA, 1984–1991 (California site) 1,760 yellow umbrellas – each 6 m high and 8.66 m in diameter

ending of that dynamic idea about the work." In this account, Christo spells out an underlying appeal present throughout their work, an appeal to our love of contingency and flux and of gradual evolution.

The most ambitious and costly project in the Christos' life as artists to date has been *The Umbrellas, Japan – USA* (1984–1991). For the first time, a project was brought to fruition in two locations simultaneously, making one work of art. The cost of the project was \$ 26 million, and the logistics were nothing short of staggering. In Japan there were 1,340 blue umbrellas; in the USA, 1,760 yellow umbrellas. Each umbrella was 6 meters high including the base and 8.66 meters in diameter, and weighed about 200 kilograms. A total volume of 7,600 liters of paint was used; the structural aluminum materials included a total length of almost 18 kilometers of umbrella poles, 24,800 umbrella ribs and struts, and 410,000 square meters of fabric in all. Needless to say, the usual permission had to be sought – from seventeen government and local community authorities in Japan, and twenty-seven in the United States, not to mention over 450 individual rice farmers and other landowners.

When all was done, when all the hard preparation had been invested and the costs borne, the umbrellas were ready to be unfurled – in rice fields, in a river, on hillsides, and in villages. "At sunrise on October 9, 1991, 1,880 workers began to open the 3,100 umbrellas in Ibaraki and California, in the presence of the artists," read the Christos' bulletin. "This Japan – USA temporary

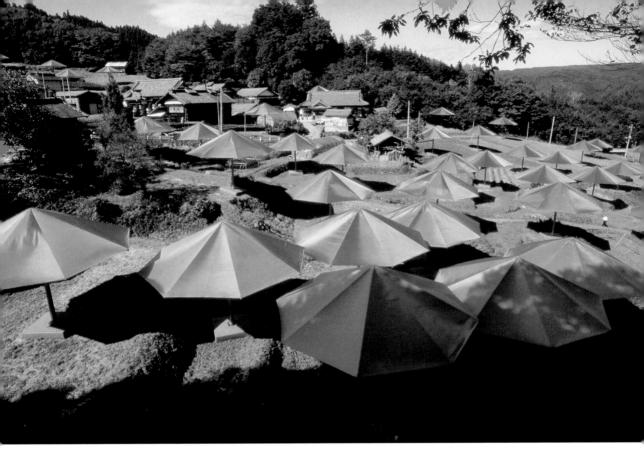

work of art reflected the similarities and differences in the ways of life and the use of the land in two inland valleys, one 19 kilometers long (12 miles) in Japan, and the other 29 kilometers long (18 miles) in the USA."

The fabric, aluminum superstructure and steel frame bases, as well as the anchors, base supports and other components, had been made by 11 manufacturers in Japan, the USA, Germany and Canada. All of the umbrellas were assembled at Bakersfield, California, and from there, the 1,340 blue umbrellas were shipped to Japan.

Beginning in December 1990, with a work force totalling 500, Muto Construction Co. Ltd. in Ibaraki, and A. L. Huber & Son in California, installed the earth anchors and bases, with work continuing through to September 1991. At that point, from September 19 to October 7, an additional construction "force" (the word is Christo's – the husband of the French general's daughter seems often to approach his tasks in an almost military style) transported the umbrellas to their bases, bolted them in, and raised them to an upright but closed position. This team was joined on October 4 by over 900 additional workers in each country – students, farm workers and friends – to complete installation. (Removal began on October 27; the land was restored to its original condition, and all the materials recycled.)

"The umbrellas," wrote the Christos, "free-standing dynamic modules, reflected the availability of the land in each valley, creating an invitational inner space, as houses without walls, or temporary settlements [...] In the precious

The Umbrellas, Japan – USA, 1984–1991 (Ibaraki, Japan site) 1,340 blue umbrellas – each 6 m high and 8.66 m in diameter

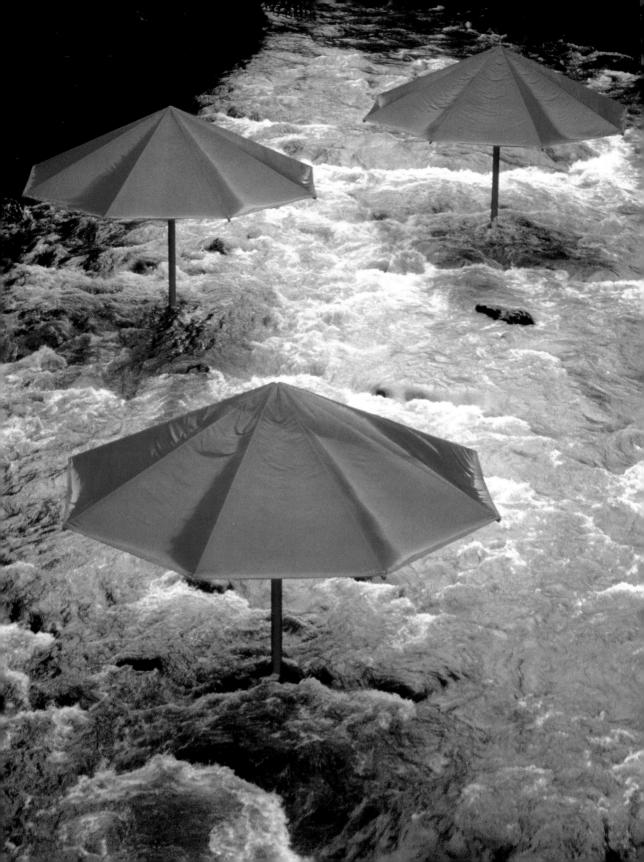

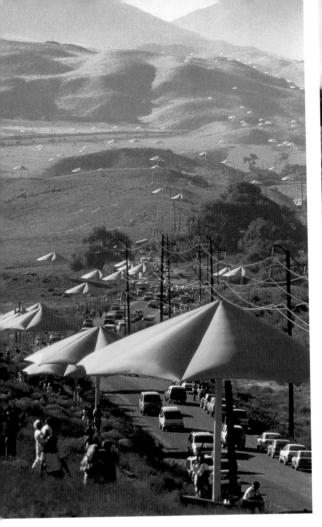

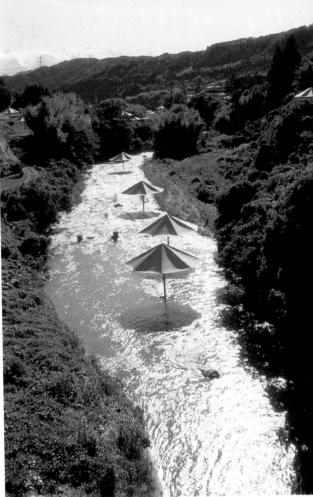

and limited space of Japan, the umbrellas were positioned intimately, close together and sometimes following the geometry of the rice fields. In the luxuriant vegetation enriched by water year round, the umbrellas were blue. In the California vastness of uncultivated grazing land, the configuration of the umbrellas was whimsical and spreading in every direction. The brown hills in California were covered by blond grass, and, in that dry landscape, the umbrellas were yellow."

It has often been suggested – with the history of the Medicis in mind, or William Golding's novel *The Spire* – that the creation of great art is inseparable from death or sacrifice. It would be tactless to suggest that the two tragic accidents that took a life at each site fitted into this pattern; the Christos shared the widespread distress. But the joy was widespread too: *The Umbrellas, Japan – USA* were a presence of simple grace and startling beauty – and, incidentally, a reminder that there was far more to the Christos' art than the wrapping they had become so closely associated with. The *Valley Curtain* (1970–1972, p. 45), *Running Fence* (1972–1976, p. 51), *Surrounded Islands* (1980–1983, p. 54) and *The Umbrellas, Japan – USA* were a new departure that took them into resplendent realms far beyond wrapping.

LEF

The Umbrellas, Japan – USA, 1984–1991 (California site)

RIGH

The Umbrellas, Japan – USA, 1984–1991 (Ibaraki, Japan site)

PAGE 72:

The Umbrellas, *Japan – USA*, 1984–1991 (Ibaraki, Japan site),

90 blue umbrellas were in the Sato River.

PAGE 74:

The Umbrellas, *Japan – USA*, 1984–1991 (Ibaraki, Japan site)

PAGE 75:

The Umbrellas, *Japan – USA*, 1984–1991 (California site)

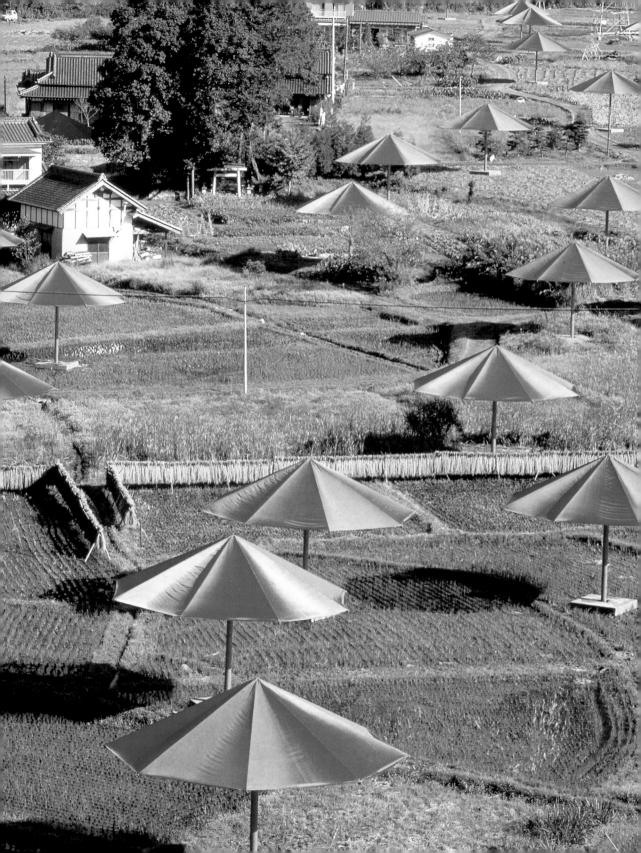

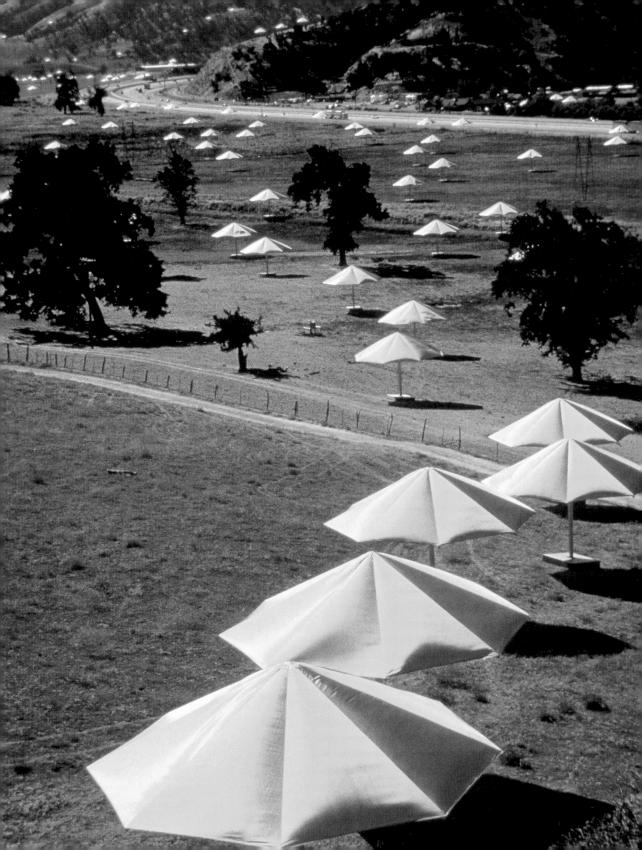

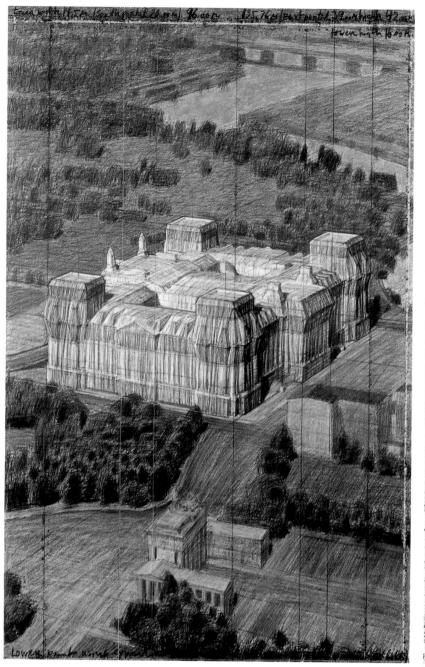

PLATSDER KERNDUKBRANDE HBURGER TOR SPREE

The Reichstag, Wrapped Trees, The Wall

Christo first expressed the idea of wrapping a parliament or a prison in October, 1961, in Paris, when he wrote a proposal for a project to wrap a public edifice. While working on *Valley Curtain* in Colorado (1970–1972, p. 38), the Christos received a postcard from Michael S. Cullen, an American living in Berlin, suggesting they wrap the Reichstag or the Brandenburg Gate. In November of that year, Jeanne-Claude wrote to Cullen informing him they were indeed interested in the idea, but they were at the time concentrating on the *Valley Curtain* project. On December 4, 1971, Christo met Cullen for the first time in Zurich, but the Christos, invariably scrupulous planners, decided that permission should be obtained before tackling the technical problems that required solutions. At that time, they hoped that the project might be carried out in the spring and summer of 1973.

The long saga of the *Wrapped Reichstag* project began in 1971 when Christo made his first drawing of a *Wrapped Reichstag*, *Project for Berlin* (1992, p. 77), while still at work on *Valley Curtain* and soon engaged in planning the *Running Fence* project. Michael Cullen established an office for the *Reichstag* project in Berlin, but it was not until February 12, 1976, that the Christos visited Berlin for the first time. Accompanied by Michael Cullen, they examined the Reichstag building and gave their first press conference, explaining among other issues, that the project (as always) would be entirely financed from the sale of drawings and collages. The Christos began meeting with Bundestag members from the CDU (Christian Democratic Union) and the SPD (Social Democratic Party). They also spoke with the president of the Bundestag, Annemarie Renger of the SPD, in June 1976.

She pointed out that the decision could not be taken by her alone. For one thing, the Allies would have a say and, with West Germany's elections coming up in November 1976, the parties had other things on their minds. In the meantime, while the Christos continued with their *Running Fence* (1972–1976, p. 51) in California, and later with *Wrapped Walk Ways* (1977–1978, p. 53), in Kansas City, Missouri, Annemarie Renger was replaced by Karl Carstens of the CDU as the new president of the Bundestag. Although the Christos received support for the project from Klaus Schulz, the mayor of West Berlin, but the Bundestag President decided against the project on May 27, 1977.

Persistence has always been one of the Christos' most striking virtues. Far from giving up, they next met with West German Chancellor Willy Brandt, who had earlier served as mayor of West Berlin. He, too, promised his support for the project. At Brandt's suggestion, the Christos lent him a collage of the Reichstag to hang in his office. The Allies, meanwhile, had decided that the wrapping of the Reichstag was a purely internal question that did not concern them. Subsequently, however, West Berlin mayor Dietrich Stobbe came out in support of the project in November 1977.

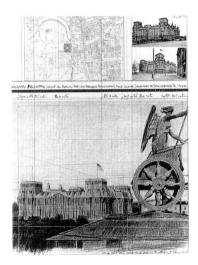

Wrapped Reichstag, Project for Berlin
Collage, 1992, in two parts
Pencil, fabric, twine, pastel, charcoal, wax
crayon, map and technical data, in two parts:
30.5 x 77.5 cm and 66.7 x 77.5 cm
Berlin, Private collection

PAGE 76

Wrapped Reichstag, Project for Berlin Drawing, 1994, in two parts Pencil, charcoal, pastel and wax crayon 165 x 106.6 cm and 165 x 38 cm Tarrytown, N. Y., Stinnes Corporation

During the full parliamentary session at the Bonn Bundestag, February 25, 1994. From left to right: Roland Specker, project manager; Sylvia Volz; Christo; Wolfgang Volz, project manager; Michael Cullen, project historian and Thomas Golden.

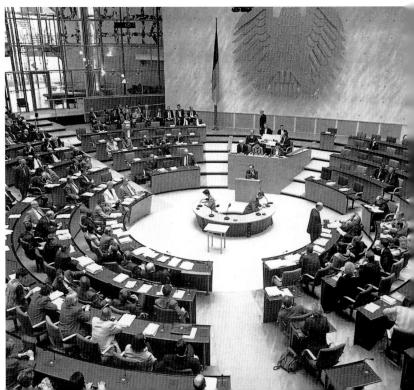

During the full parliamentary session at the Bonn bundestag, 1994

The Christos held their first exhibition of collages and drawings of the Wrapped Reichstag, Project for Berlin, at the Annely Juda Gallery in London. At the same time, parallel to the completion of Wrapped Walk Ways, the Christos began planning The Mastaba of Abu Dhabi, Project for the United Arab Emirates (p. 88) and The Gates, Project for Central Park, New York City (p. 91). They also completed Surrounded Islands (1980–1983, p. 54). While exhibiting at the Ludwig Museum in Cologne, and later visiting Berlin to revive the interest in the *Reichstag* project, the Christos met with Richard von Weizsäcker, who subsequently became president of Germany; he, too, promised his support. Meanwhile, in 1984, after 10 years of arduous negotiations, Jacques Chirac, then mayor of Paris, gave the go-ahead for The Pont Neuf Wrapped (1975-1985, p. 65) project. The Christo's also started initial preparations for The Umbrellas, Japan - USA (1984-1991, p. 70/71). Bundestag president Rainer Barzel (CDU), a supporter of the project, resigned, only to be succeeded by Philipp Jenninger, who withheld his support. In 1985, West German Chancellor Helmut Kohl came out firmly against the project.

A great turning point came with the fall of the Berlin Wall in November 1989. Now the Christos felt more confident about the realization of the project. On October 3, 1990, Germany was reunited and on June 20, 1991 the Bundestag voted to make Berlin again the capital of united Germany and to move the seat of Government from Bonn to Berlin. Although Willy Brandt, who had been a great supporter of the Christo project, died in 1992, the president of the Bundestag, Rita Süssmuth, had already declared her full support for the project in 1991 and assured the Christos that she would fight hard for its realization. Accordingly, she opened the Christos' exhibition for the project at the Marstall Art Academy in Berlin. However, on January 11, 1993, both Chancellor Kohl and Wolfgang Schäuble, CDU/CSU Majority Whip in the Bundestag, publicly announced their opposition to the Christos' project. At the same time an architectural jury for the restoration of the Reichstag came out in favor of the wrapping of the Reichstag and forwarded its recommendations to the Bundestag. At the suggestion of Rita Süssmuth, a scale model of the project, along with an architectural design for the renovation of the Reichstag, was placed on display in the lobby of the Bundestag.

LEFT:

Member of the German Bundestag Peter Conradi (SPD) during his speech in favor of the *Wrapped Reichstag*, 1994

CENTER:

Cover page of the transcript of the debate and vote of session number 211 of the German Parliament, 1994

RIGHT

During an 18-minute-speech, Wolfgang Schäuble (CDU) tried to rally his party against the *Wrapped Reichstag*, 1994

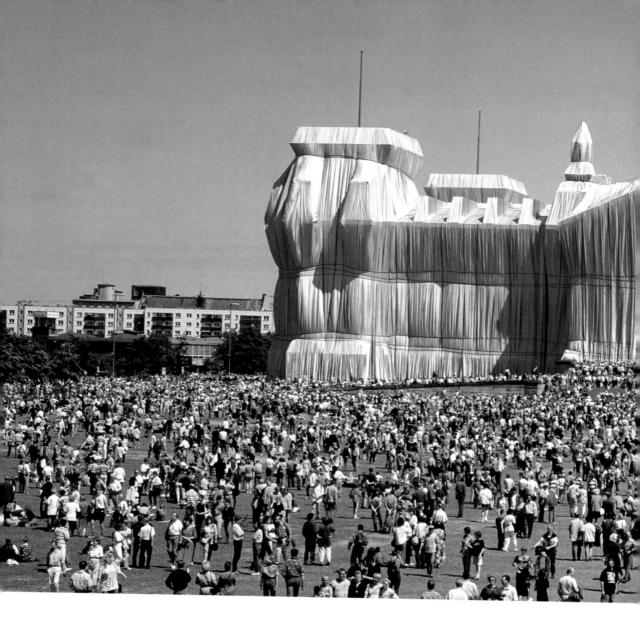

Wrapped Reichstag, Berlin, 1971–1995 West façade Polypropylene fabric and blue rope Finally, on February 25, 1994, the Bundestag voted to give the Christos permission to proceed with their project. With this decision, years of lobbying and hard work finally came to an end. As the Christos pointed out, they had been engaged in the creation of visually exciting artworks for 30 years: "We are not tragic persons. We do not do tragic things. The Reichstag will be no different, we make very stimulating things unlike steel, or stone, or wood the fabric catches the physicality of the wind, the sun, the works are refreshing and then they are quickly gone." When asked, why wrap the Reichstag at all, Christo replied, "I had a special interest in Germany because I had my first personal exhibition in Cologne in 1961, and since 1958, I have had a great number of collectors, museum people, critics, and friends in Germany who are interested in my work so there was a natural relationship with the German

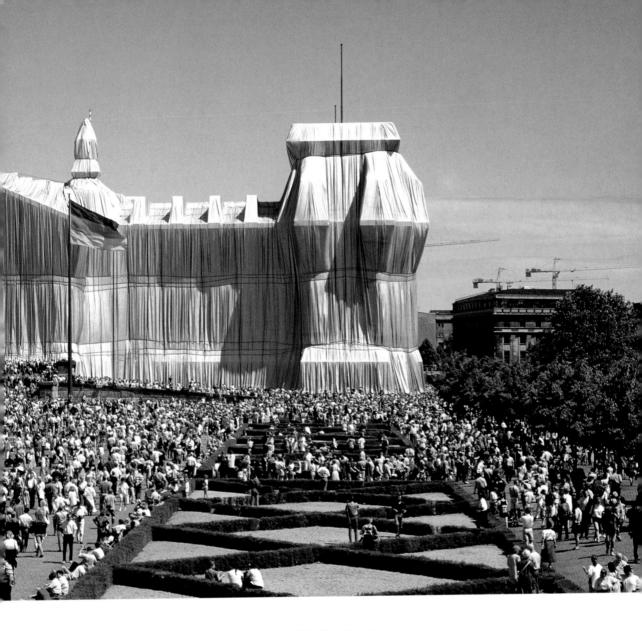

art scene and German culture in general." Furthermore, "the first *Running Fence* idea was to have a fence along the Berlin Wall, and there are some drawings from between 1970–1972 of a fabric fence in West Berlin, hiding the wall ... that was my first project for Berlin," added Christo.

The Reichstag building, which stands in an open metaphysical area, had undergone continuous changes. Alert to the environmental, social, political, and other implications of the project, Christo and Jeanne-Claude have remained true to the ideal of the artist as a great, and above all, autonomous, maker.

In September 1994, after getting the green light and under the supervision of Wolfgang and Sylvia Volz and Roland Specker, ten companies in Germany started manufacturing all the various materials called for by the specifications of the engineers. The iron framework was installed in April, May, and June

Wrapped Reichstag, Project for Berlin Collage, 1994
Pencil, enamel paint, charcoal, wax crayon, ballpoint pen, map, photograph by Wolfgang Volz, tape and fabric sample on brown/grey cardboard, 35.5 x 28 cm
New York, Collection Adrian Keller

1995 – that is, the steel structures for the towers, roof, statues, and the stone vases, necessary to allow the folds of the fabric to cascade from the roof to the ground. One hundred thousand square meters of thickly woven polypropylene fabric with an aluminum surface and 15,600 meters of blue polypropylene rope, 3.2 cm in diameter, were needed to wrap the Reichstag. A crew of 90 professionals and 120 installation workers brought to completion the Christos' 25-year struggle to realize this project, whose planning had stretched from the mid-1970s to the mid-1990s. The façades, the towers and the roof were covered by 70 tailor-made fabric panels – twice as much fabric as the surface of the building. Over a period of hours, many thousands of observers watched and applauded as the fabric was unfurled.

Built in 1894, burnt in 1933, almost destroyed in 1945, restored in the 1960's, the Reichstag is a symbol that, like no other, represents the heights and depths of German history.

Throughout the history of art, from ancient times to the present, the use of fabric has always fascinated artists. Formed into folds, pleats, and draperies, fabric constitutes an important element in many paintings, frescos, reliefs and sculptures made of wood, bronze or stone. The use of fabric to wrap the Reichstag follows in the classical tradition: like clothing or skin, the fragility of fabric transmits the unique quality of impermanence.

Huge crowds came from all over the world, and stayed all night. Some viewers played musical instruments, or danced and sang, as they watched the unfolding of this great drama, which transformed the Reichstag into a huge and beautiful temporary sculpture. Very few people in the crowd were against the project. Twelve hundred monitors, mainly students, patrolled the area in round-the-clock shifts and distributed square snippets of the fabric to the public as souvenirs. The cost of the project was \$ 13 million, financed by the Christos from the sale of drawings, collages and scale models of their many projects.

For a period of two weeks, the richness of the silvery fabric, shaped by the blue ropes, created a great flow of vertical folds that highlighted the features and proportions of the imposing building. On June 24, 1995, the wrapping of the Reichstag was complete. It was a dramatic experience of sheer beauty and high art.

Two weeks and five million visitors later, despite a request from Bonn to extend the duration of the project, the building was undraped and the materials recycled. The work of British architect Sir Norman Foster in reshaping the building once more into Germany's parliament could now begin. Christo explains, "All our projects have a very strong nomadic quality, like the nomadic tribes that build their tents, by using this vulnerable material, there is a greater urgency to be seen- because tomorrow it will be gone... nobody can buy those projects, nobody can own them, nobody can commercialize them, nobody can charge tickets to see them, even ourselves, we do not own these works. Our work is about freedom. Freedom is the enemy of possession, and possession is the equal of permanence. This is why the work can not stay." The wrapping of the Reichstag, one of the Christos' most glorious projects, is the high point of the long careers of Christo and Jeanne-Claude.

Wrapped Trees (1997–1998, p. 84) have been a part of Christo's and Jeanne-Claude's work since the mid–1960s. Christo first proposed *Project for a Wrapped Tree* in 1964, but the sculpture was not realized. The preliminary collage for this work reveals the artist's interest in the living form of trees; he utilizes fabric, polyethylene, rope and various types of twine to bind and conceal the organic roots and the top of the tree, leaving the trunk bare to display its raw form and thus giving the viewer a glimpse of the actual tree. A

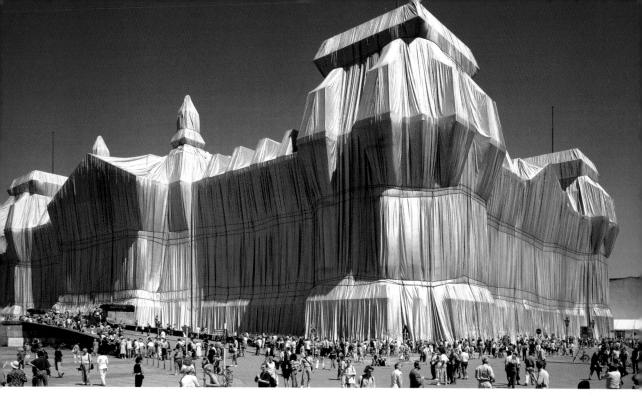

Wrapped Tree was finally completed in 1966 at the Stedelijk van Abbe Museum, Eindhoven, The Netherlands. This sculpture was created from an uprooted tree, 10 meters high with a diameter of 63.5 centimeters. During the same year, Christo and Jeanne-Claude proposed their first project for Wrapped Trees, Project for Forest Park, Saint Louis, Missouri. In spite of their tenacity, permission to undertake the project was denied. The artists subsequently persisted in a great number of attempts at executing a project utilizing trees.

In 1967, the artists proposed Wrapped Trees, Project for the Fondation Maeght, Saint-Paul-de-Vence, France, and once again permission was refused. The preliminary collages for this project show three standing oak trees bound together as one living, yet self-contained, unit. Later that year, Christo was able to wrap two uprooted trees at the Fondation Maeght. Christo and Jeanne-Claude still desired to realize a temporary work of art with standing trees, so they continued proposing projects such as Wrapped Trees, Project for the Museum of Modern Art, New York; Wrapped Trees and Sculpture Garden, Project for the Museum of Modern Art, New York in 1968; Wrapped Trees, Project for the Avenue Champs Elysées, Paris (1968–1969); Two Wrapped Trees, Project for the Garden of Peppino Agrati, Veduggio, Italy (1970–1971); and Wrapped Tree, Project for the Museum Würth, Künzelsau, Germany in 1994.

Each of these proposed projects differed in detail. The trees proposed for the Museum of Modern Art are growing in a contrived space separated by a wall. In the scale model, the upper parts of the trees are wrapped, but the trunks are left unwrapped. In contrast, the trees for the Sculpture Garden of the Museum of Modern Art are enclosed indoors and would be totally wrapped, along with the floor. This simultaneous wrapping would join the trees and floor as an integral part of the space. The ambitious 330 trees that the artists desired to wrap on the Champs Elysées are lined up like soldiers, as

Wrapped Reichstag, Berlin, 1971–1995 West and south façades Polypropylene fabric and blue rope

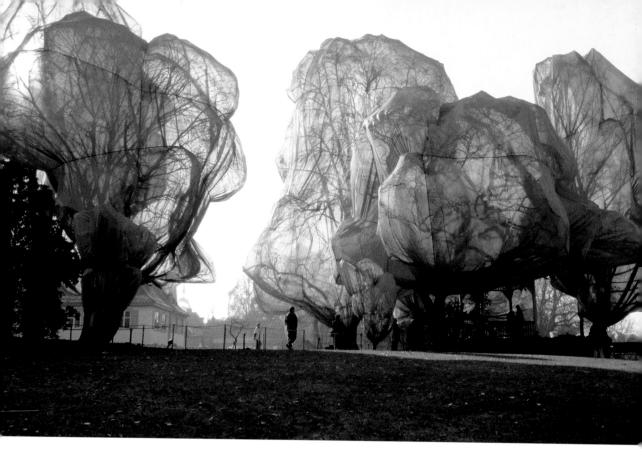

Wrapped Trees, Fondation Beyeler and Berower Park, Riehen, Basel, Switzerland, 1997–1998

Polyester fabric and acrylic rope

though they are guarding the busy city streets of Paris. In comparison, the project for the less rigid space in the garden of Pepino Agrati would only utilize two trees, and that for the Museum Würth calls for only a single tree. Christo and Jeanne-Claude have been unable to realize any of these projects, however, because permission has been denied.

During these years, the Christos have been able to create a number of other sculptures with uprooted trees. In 1968, in Greenwich, Connecticut, they wrapped a 17.7-meter tree with a diameter of 91 centimeters, and in 1969 in Sydney, Australia, they created *Two Wrapped Trees* for the collector John Kaldor, one with a height of 9.5 meters and the other 5.18 meters; both trees had a diameter of and 91 centimeters. Also, in 1969, Christo did a *Wrapped Tree* at the Museum of Contemporary Art in Chicago, Illinois. For each of these sculptures, various fabrics and types of rope and twine were used to carefully wrap the roots and tops of the trees, leaving bare the bark of the trunk. These sculptures reveal trees submissively bound, lying supine.

Christo and Jeanne-Claude's history of working with trees as well as their persistence in wanting to create a work of art with standing trees continued for 30 years before they finally received permission in 1997 for *Wrapped Trees, Fondation Beyeler and Berower Park, Riehen, Switzerland* (1997–1998). During the two years of planning for this project, the artists carefully selected the 178 trees to be wrapped, along with the fabric and rope. They tirelessly worked with their collaborators Wolfgang Volz and Josy Kraft to plan the project. They took measurements, created patterns for each individual tree, sewed

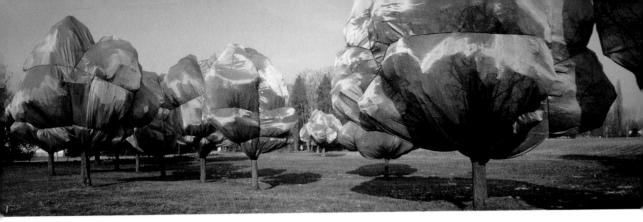

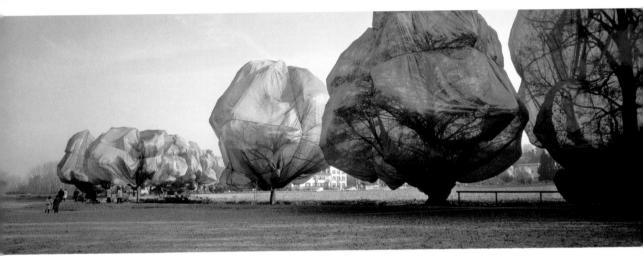

the fabric, and shipped it to Riehen. On November 13, 1998, this ambitious project was realized with 55,000 square meters of woven polyester fabric and 23.1 kilometers of rope. The height of the trees varied between 25 meters and 2 meters, and the diameters ranged from 14.5 meters to 1 meter. The translucent fabric revealed the tree branches pushing outward as though mother nature were sensually presenting herself to the onlookers.

Wrapped Trees remained extant for 3 weeks during the changing autumn weather: sunshine, sunset, frost, rain and snow. The artists have stated that, "The temporality of a work of art creates a feeling of fragility, vulnerability, and an urgency to be seen, as well as a presence of the missing, because we know it will be gone tomorrow. The quality of love and tenderness that human beings have towards what will not last, for instance, the love and tenderness for childhood and our lives, is a quality we want to give to our work as an additional aesthetic quality." Susan Astwood, a close collaborator of Jeanne-Claude's, explains, "After so many years of anticipation, Christo and Jeanne-Claude's poetic project proves why this tremendous amount of work and money is worth it to them. Christo and Jeanne-Claude do not work for financial gain or to leave a permanent monument to their egos. Just as parents work unselfishly to provide for their children, the artists work to finance their projects. Their expenses and long days of work are repaid only in the joy and beauty they derive from seeing their projects realized."

Wrapped Trees, Fondation Beyeler and Berower Park, Riehen, Basel, Switzerland, 1997–1998 Polyester fabric and acrylic rope

The Wall, Project for Gasometer, Oberhausen, Germany Drawing, 1999 Pencil, enamel paint, pastel, charcoal and tape, 77.5 x 70.5 cm

Since 1958 the use of oil barrels has also had a tradition in the work of Christo and Jeanne-Claude. Wrapped Oil Barrels (1958); Stacked Oil barrels and Dockside Packages (1961, p. 20) in Cologne, Germany; Barrels Structures 1962 in Gentilly, France; and Wall of Oil Barrels – Iron Curtain, Rue Visconti, Paris (June 1962, p. 14); 56 Oil Barrels Construction (1967), donated by Martin and Mia Visser to the Kröller-Müller Museum, Otterlo, The Netherlands; and The Mastaba of 1,240 Oil Barrels (1968), Institute of Contemporary Art, Philadelphia. In 1979, Christo and Jeanne-Claude started work on The Mastaba of Abu Dhabi, Project for the United Arab Emirates, (1979, p. 88), a structure of 400,000 oil barrels. With a total height of 150 meters and a base of 300 meters by 225 meters, this project has yet to be completed.

The Gasometer in Oberhausen, Germany is considered one of the largest gas tanks in the world: 110 meters in height and 68 meters in diameter. It was built in 1928 to store gas formed as a by-product in the industrial production of iron ore. In 1998, the IBA Emscher Park Organization, which had been founded by the state of North Rhine – Westphalia to improve the infrastructure in the Ruhr area, invited the Christos to mount two documentary exhibitions of *The Umbrellas, Japan – USA* (1984–1991, p. 70/71) and *Wrapped Reichstag, Berlin* (1971–1995, p. 80). *The Wall, 13,000 Oil Barrels, Oberhausen* (1999, p. 87), was an installation and not a project. 26 meters in height, 68 meters in diameter, and 7 meters deep, the wall was a multi-layered work of art formed of 13,000 stacked oil barrels painted in glowing colors of bright yellow, orange, blue, green, white, and gray. The total weight of the project was 300 tons.

The Wall followed in the tradition of the Christos' other projects, in a certain sense closing a circle of works involving oil barrels begun by the Christos in 1958. The Wall in Oberhausen, constructed between January 8 and April 6, 1999, stood on exhibition for 5 months. At the end of the installation, it was dismantled, and the barrels were repainted and returned to their function in the petrochemical industry.

The sight of the brightly colored wall in contrast to the dark walls surrounding it offered the viewer another unusual and unforgettable experience.

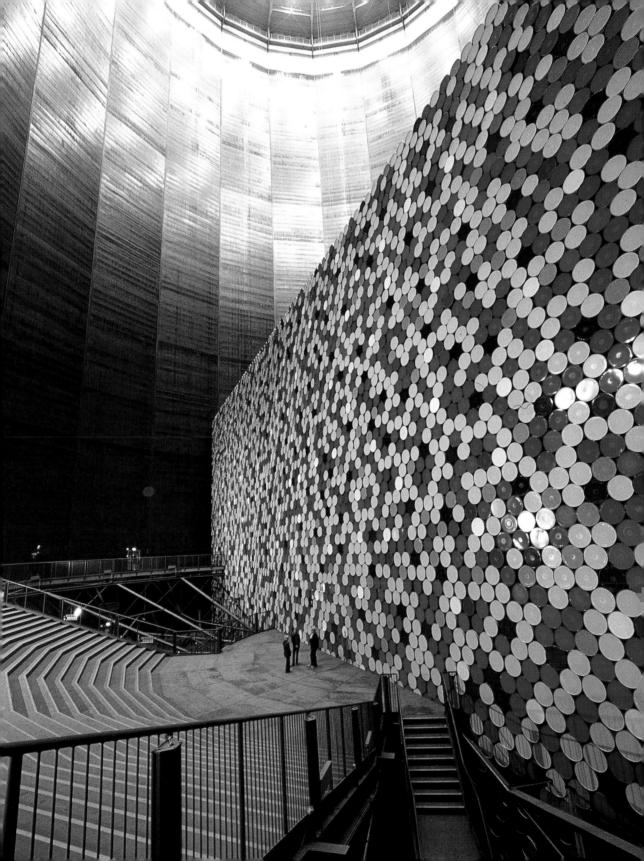

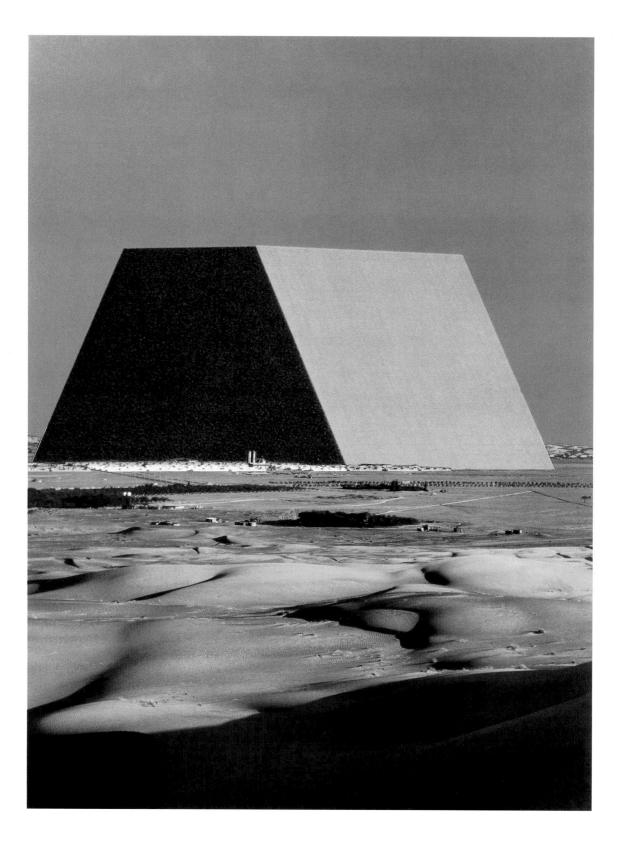

"This is reality"

Work in progress

The Christos are not artists who stand still. In keeping with the emphasis on temporary states, their work is forever moving on from one project to the next; and their works in progress inevitably overlap. Even as the Reichstag project was realized at long last, the Christos are absorbed in other ideas, some of which have occupied them for years. There is something monumental in this ability to conceive art across long time spans.

The works by the Christos currently in progress are *The Mastaba of Abu Dhabi, Project for the United Arab Emirates* (p. 88); *The Gates, Project for Central Park New York City* (p. 90); and *Over the River, Project for the Arkansas River, State of Colorado* (p. 92).

The *Mastaba* project has a prehistory. A mastaba was an ancient architectural form (a tomb) with two vertical walls, two slant walls, and a flat top. In 1968, the Christos made their first project with this title, consisting of over 1,200 oil barrels, in connection with their exhibition at the Institute of Contemporary Art in Philadelphia. The structure – over 6 meters high, 9 meters wide, and 12 meters deep – was installed inside the Museum. Then, in 1969 the Christos worked on a mastaba for Houston, Texas, consisting of 124,000 barrels. Christo produced drawings, pastels and collages, but the project was not realized.

The Mastaba of Abu Dhabi is conceived as a symbol of the Emirate and of the greatness of Sheikh Zayed, according to the Christos' release, and of "the civilization of oil throughout the world." It is planned to be higher and more massive than the Pyramid of Cheops near Cairo. There is a self-evident logic, of course, in choosing the world's greatest oil-producing center, the Gulf, as the site for a project that will use almost 400,000 oil barrels. Another logic of a more whimsically appealing nature lies in the proposed accord between oil barrels of many and various colors and Islamic tile mosaics: this level of analogy arguably makes *The Mastaba of Abu Dhabi* one of the Christos' most challenging projects.

A mastaba was originally an ancient Egyptian tomb in which offerings were made in an outer chamber. In an inner chamber would be a figure of the deceased person, with a shaft leading down to the grave proper. In other words, a mastaba had a purpose: sacred, ritual, devotional, it was a monument that served memory and honor.

Their projected *Mastaba* is quite unlike this; its sole purpose is to exist, as a large sculptural artefact. The barrels, lain horizontally on their sides, will (if the project is realized) add up to a total structure so large that a number of forty-story skyscrapers could comfortably be fitted into the volume; but there will be no ingress except for a passageway to an elevator to take visitors to the top, 150 meters above ground level, from where they will enjoy views 50 kilometers into the surrounding country. The sense of occasion, the experience of the thing, will be its entire purpose.

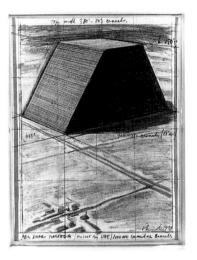

The Mastaba of Abu Dhabi, Project for the United Arab Emirates
Drawing, 1978
Pencil, charcoal, pastel and wax crayon, 71 x 56 cm
Private collection

PAGE 88-

The Mastaba of Abu Dhabi, Project for the United Arab Emirates (detail)
Collaged photograph, 1979, 56 x 35 cm

The Gates, Project for Central Park, New York City
Drawing, 1991, in two parts
Pencil, charcoal, pastel, wax crayon and map 203.6 x 38 and 203.6 x 106.6 cm

The Gates, Project for Central Park, New York City

In 1980, in a rented field outside of Boulder, Colorado, Christo and Jeanne-Claude arranged for three life-size tests to be conducted by Theodore Dougherty, President of A. and H. Builders; and engineers Dr. Ernest C. Harris, Sargis Safarian and Dimiter Zagoroff.

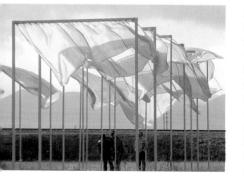

The walkways' area approaching the *Mastaba* will strike the visitor as an oasis, with its flowers and grass. Palm trees, eucalyptus, thorns and other shrubs will also be planted around the mastaba at some distance, to serve as a windbreak, minimizing the force of sandstorms and winds. The project description envisions a "worship room" (as well as parking and other facilities) in this somewhat distant area; the mention of worship is a tactful reminder of the original function of such structures, and a courtesy to the Islamic world, but at present, despite the Christos' having published a detailed exhibition catalogue in Arabic, the project has not been approved.

The Gates project represents a lighter side of the Christos' work, the side seen so well in *The Umbrellas* or *Surrounded Islands*, rather than the monumental side that has repeatedly been drawn to massive architectural structures. *The Gates* are planned to be about five meters high, the width varying to suit the width of the paths, and will be set up on the pathways of Central Park, spaced at intervals of about three meters. Attached to the top of each steel frame will be a safran-colored fabric panel; in the right breeze, these synthetic woven panels will wave aloft towards the next gate.

When the Christos originally conceived the project in 1979, they hoped that installation could be effected for a fortnight in October 1983 or 1984; but in fact the project has yet to be realized. At the time, they provided written undertakings that neither New York City nor the park would bear any of the expenses, and proposed drawing up a contract similar to that made with the authorities in California for the Running Fence project. Such a contract would require the Christos to provide personal and property insurance exempting the Department of Parks from all liability; to prepare a statement on the project's environmental impact, if required; to restore all the park territory involved to its original state after the removal of The Gates; and, throughout, to cooperate fully with all the relevant authorities. The Christos proposed to employ only Manhattan residents for the work, to pay the cost of Park supervision, and to guarantee access for maintenance and all emergency vehicles. They also assured that no rock or vegetation formations would be disturbed, or wildlife patterns interfered with. In a word, the Christos made their proposal in a manner that has become tantamount to a trademark: well thought out, scrupulous, considerate, diplomatic, and, above all, with an attractive sense of organized responsibility. The tactics have become part of the art.

The Gates project would underline the organic, in an airy contrast with the geometrical grid of Manhattan. It would complement the beauty of Central Park. At present, though, the project remains unrealized. In 1981, after the Christos had submitted detailed proposals and studies, the City Commissioner of Parks unfortunately issued a 165-page report refusing permission.

Over The River, Project for the Arkansas River, Colorado (1992, p. 92), began in 1992. The Christos and their collaborators traveled 22,530 kilometers through the Rocky Mountains in August 1992, 1993, and 1994 searching for a site, namely, a river with a high banks to enable steel cables and fabric panels to be suspended horizontally above the water. Steel wire cables, anchored on the upper parts of the river banks, would cross the river and serve as attachment for the fabric panels, which were to follow the configuration and width of the changing course of the river. The woven fabric panels, sewn in advance with rows of grommets at the edges, mounted perpendicularly 3–7 meters above the surface of the river bed, would create shimmering waves of fabric. For aesthetic reasons, the stream of successive panels, 11 kilometers long, was to be interrupted by bridges, rocks, trees, and bushes, creating abundant flows of light.

The Gates (project for Central Park, New Yorak GTY 11000-15,000 steel gates, along 26 ml. selected walk mays

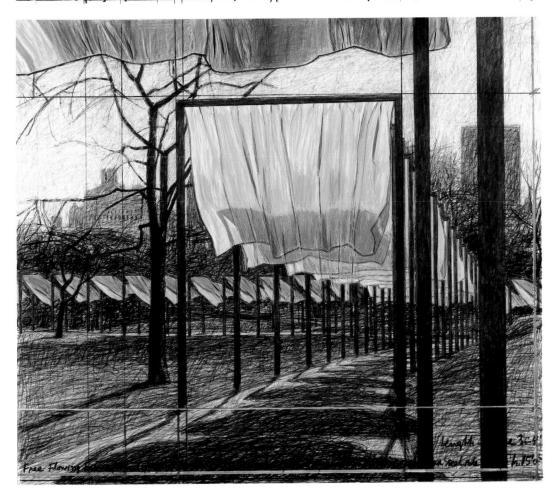

The Gates, Project for Central Park, New York City
Collage, 1999, in two parts
Pencil, fabric, pastel, charcoal, wax crayon and aerial photograph,
30.5 x 77.5 and 66.7 x 77.5 cm

Over the River, Project for the Arkansas River, State of Colorado

Drawing, 2000, in two parts Pencil, pastel, charcoal, wax crayon, handdrawn topographic map and tape, 38 x 165 and 106.6 x 165 cm

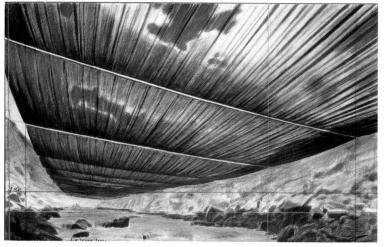

Wide clearance between the banks and the edges of the fabric panels created an interplay of contrasts, allowing sunlight to illuminate the river on both sides. When seen from underneath by a person standing on the rocks at the edge of the river, or viewed at water level by rafters, the luminous and translucent fabric would highlight the contours of the clouds, the mountains, and the vegetation.

The project required a river with a continuous road running parallel along the banks, as well as white and tranquil waters suitable for rafting and canoeing. The Christos inspected 89 rivers in seven states. After touring the site in the summer of 1996, the Arkansas River in Colorado was chosen as the most appropriate for the project.

Running along the river, the road and footpaths will allow the project to be seen, approached, and enjoyed from underneath, on foot and by raft, or from above by car. The project will last two weeks and, as with all previous projects, *Over The River* will be entirely financed by Christo and Jeanne-Claude from the sale of preparatory drawings, lithographs, collages, and early works. After two weeks, all materials will be removed and recycled. Christo has created many sumptuous drawings for the project, which promises to be a great one.

In a working life in art that now spans over five decades, Christo and Jeanne-Claude have created a vast and diverse body of work, and, while never ceasing to attract controversy, now number not only among the best known but also (a rare gift) among the most loved and respected of contemporary artists. The global scope of their artistic thinking is apparent both in their striking choices of locations and in their undauntedness in the face of difficulties. Global scope too often implies commercial trivialization, but the Christos are quick to make the necessary distinctions. "Most art", Christo has observed, "comes in the form of blockbuster exhibitions, which are little better

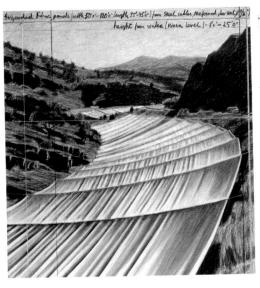

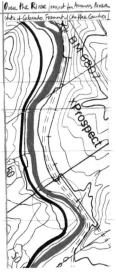

Over the River, Project for the Arkansas River, State of Colorado

Collage, 1999, in two parts

Pencil, fabric, pastel, charcoal, wax crayon and

topographic map, 77,5 x 66,7 and 77,5 x 30,5 cm

than Disneyland. Our projects are once-in-a-lifetime experiences. They are about freedom. Our bourgeois society has the notion of art as merchandise available only to limited audiences. With our art you do not need tickets to see it." In this antipathy to conventional ideas of art consumption, we can detect both Christo's roots in the Communist bloc and an entirely individual determination to serve populist ideals of universal availability.

"When we are asked by painters or sculptors how we can work for 4 or 6 or 10 or 21 years on the same project, they do not realize what is inherent to each one of our works, they would not ask the same question to architects or urban planners, because it is obvious that creating a bridge, a skyscraper, a highway or an airport does take many years."

I shall give Christo himself the last word. Interviewed by *Balkan Magazine* (November/December 1993) he remarked: "Our projects are not something out of fantasy. Fantasy is what we find in the cinema and the theatre, our imaginative notion of things. But when we feel the real wind, the real sun, the real river, the mountain, the roads – this is reality, and we use it in our work. Our projects carry that reality."

Over the River, Project for the Arkansas River, State of Colorado

The last of four life-size tests was conducted outside of Grand Junction, Colorado in June – August 1999. A total of 17 fabric panels were tested between 1997 and 1999.

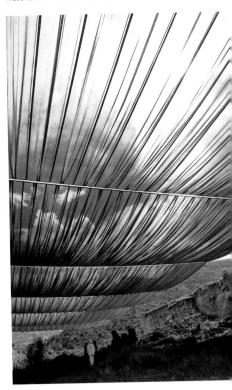

Christo and Jeanne-Claude – Chronology

1935 Christo: born Christo Javacheff, June 13, Gabrovo, of a Bulgarian industrialist family.

Jeanne-Claude: born Jeanne-Claude de Guillebon, June 13, Casablanca, of a French military family.

1952 Jeanne-Claude: Baccalauréat in Latin and Philosophy, University of Tunis.

1953 Christo: studies at Fine Arts Academy, Sofia.

1956 Christo: arrival in Prague.

1957 Christo: one semester's study at the Vienna Fine Arts Academy.

1958 Christo: arrival in Paris where he meets Jeanne-Claude. *Packages* and *Wrapped Objects*.

1960 Birth of their son, Cyril, May 11.

1961 Project for a Wrapped Public Building. Stacked Oil Barrels and Dockside Packages, Cologne Harbor. Their first collaboration.

1962 Wall of Oil Barrels – Iron Curtain blocking the Rue Visconti, Paris. Stacked Oil Barrels in Gentilly, near Paris. Wrapping a Girl, London.

1963 Showcases

1964 Establishment of permanent residence in New York City. *Store Fronts*.

1966 Air Package and Wrapped Tree, Stedelijk van Abbe Museum, Eindhoven. 1,200 Cubic Meter Package, Walker Art Center, Minneapolis School of Art.

1968 Wrapped Fountain and Wrapped Medieval Tower, Spoleto.
Wrapping of a public building, Kunsthalle Berne.

5,600 Cubic Meter Package, documenta IV, Kassel 1967–1968, an Air Package 85 meters high, 10 meters in diameter. Corridor Store Front, total area: 139 square

1,240 Oil Barrels Mastaba, and Two Tons of Stacked Hay, Philadelphia Institute of Contemporary Art.

1969 Museum of Contemporary Art, Chicago, Wrapped. Wrapped Floor and Stairway. 260 square meter drop cloths. Museum of Contemporary Art, Chicago. Wrapped Coast, Little Bay, Australia, 1968–1969, 92,900 square meters, erosioncontrol fabric and 56 kilometers of ropes. Project for Stacked Oil Barrels, Houston Mastaba, Texas. 1,249,000 barrels. Project for Closed Highway.

1970 Wrapped Monument to Vittorio Emanuele, Piazza del Duomo, Milan, and Wrapped Monument to Leonardo da Vinci, Piazza della Scala, Milan.

Jeanne-Claude and Christo in Kansas City, 1978

Christo and Jeanne-Claude in Miami, 1983

1971 Wrapped Floors and Covered Windows, Museum Haus Lange, Krefeld, West Germany. Start of Wrapped Reichstag. Project for Berlin.

1972 *Valley-Curtain, Rifle, Colorado, 1970–1972.* Width: 381 meters, height: 111 meters.

1974 The Wall. Wrapped Roman Wall, Via Veneto and Villa Borghese, Rome.
Ocean Front, Newport, Rhode Island.
14,000 square meters of floating polypropylene fabric over the ocean.

1976 Running Fence, Sonoma and Marin Counties. California. 1972–1976, 5.5 m high, 39.5 km long, 200,000 square meters of woven nylon fabric, 145 km of steel cables, 2,060 steel poles (each: 9 cm in diameter, 6.4 meters long).

1978 Wrapped Walk Ways, Jacob L. Loose Park, Kansas City. Missouri, 1977–1978, 12,540 square meters of woven nylon fabric over 4.5 km of walkways.

1979 The Mastaba of Abu Dhabi, Project for the United Arab Emirates (in progress).

1980 The Gates, Project for Central Park, New York City (in progress).

1983 Surrounded Islands, Biscayne Bay. Greater Miami. Florida, 1980–1983, 603,850 square meters of pink woven polypropylene fabric.

1984 Wrapped Floors and Stairways of Architecture Museum, Basle, Switzerland.

1985 *The Pont Neuf Wrapped. Paris,* 1975–1985, 40,876 square meters of woven polyamide fabric. 13 kilometers of rope.

1991 *The Umbrellas, Japan – USA,* 1984–1991, 1,340 blue umbrellas in Ibaraki, Japan; 1,760 yellow umbrellas in California, USA. Height: 6 meters, diameter: 8.66 meters.

1992 Over The River, Project for Western USA (in progress).

1995 Wrapped Floors and Stairways and covered Windows, Museum Würth, Künzelsau, Germany. Wrapped Reichstag Berlin, 1971–1995. 100,000 square meters of polypropylene fabric, 15,600 meters of rope and 200 tons of steel.

1998 Wrapped Trees, Fondation Beyeler and Berower Park, Rihen, Basel, Switzerland, 1997–1998

1999 *The Wall, 13,000 Oil Barrels.* Indoor installation at the Gasometer, Oberhausen, Germany.

Christo and General Jacques de Guillebon, Jeanne-Claudes father, 1976

In front of The Pont Neuf Wrapped, 1985

Jacob Baal-Teshuva (born 1929), author, critic and independent curator of museum shows, has been a friend of Christo and Jeanne-Claude for many years. He attended many of their projects since the 70s. He is the author of *Christo and Jeanne-Claude. The Reichstag and Urban Projects* and has curated an exhibition about their work in KunstHausWien, Vienna, Villa Stuck, Munich and Museum Ludwig, Aachen. He also published books on Marc Chagall, Andy Warhol, Alexander Calder, Jean Michel Basquiat, and Louis Comfort Tiffany. Jacob Baal-Teshuva lives and works in New York and Paris.

Wolfgang Volz (born 1948) has been working with Christo and Jeanne-Claude since 1972. He is responsible for, among other things, the photography of the works of art. During the projects *Wrapped Reichstag*, *Wrapped Trees* and the installation *The Wall*, he was technical director for the realization of the works of art. This close collaboration has resulted in many books and more than 300 exhibitions in museums and galleries around the world. Wolfgang Volz and his wife and partner Sylvia Volz live and work in Düsseldorf.

The publisher wishes to thank Christo, Jeanne-Claude and Wolfgang Volz for their support and encouragement in the preparation of this book. In addition to the collections and institutions named in the captions, the following acknowledgements are also due to the photographers:

Klaus Baum: 33 Ferdinand Boesch: 28 Jeanne-Claude Christo: 34, 50, 59, 61, 95 Thomas Cugini: 35 Eava-Inkeri:10, 11, 12, 13, 16, 23, 24, 25, 28, 48, 59 Gianfranco Gorgoni: 46, 48 André Grossmann: 49, 79, 88 Carroll T. Hartwell: 31 Jean-Dominique Lajoux: 14 Raymond de Seynes: 29 Harry Schunk: 18, 19, 21, 25, 30, 32, 35, 36, 37, 38, 39, 40, 41, 42, 43, 45, 46, 47 Wolfgang Volz: 1, 2, 6, 7, 9, 17, 22, 23, 26, 49, 51, 52, 53, 54, 55, 56, 57, 58, 60, 62, 63, 64, 65, 66, 67, 68, 69, 70, 71, 72, 73, 74, 75, 76, 77, 78 (Aleks Perkovic), 79 (Aleks Perkovic), 80/81, 82, 83, 84, 85, 86, 87, 88, 89, 90, 91, 92, 93, 94, 95
John Webb: 21

John Webb: 21 Stephan Wewerka: 20 Dimiter Zagoroff: 44